HASSELBLAD & THE MOON LANDING

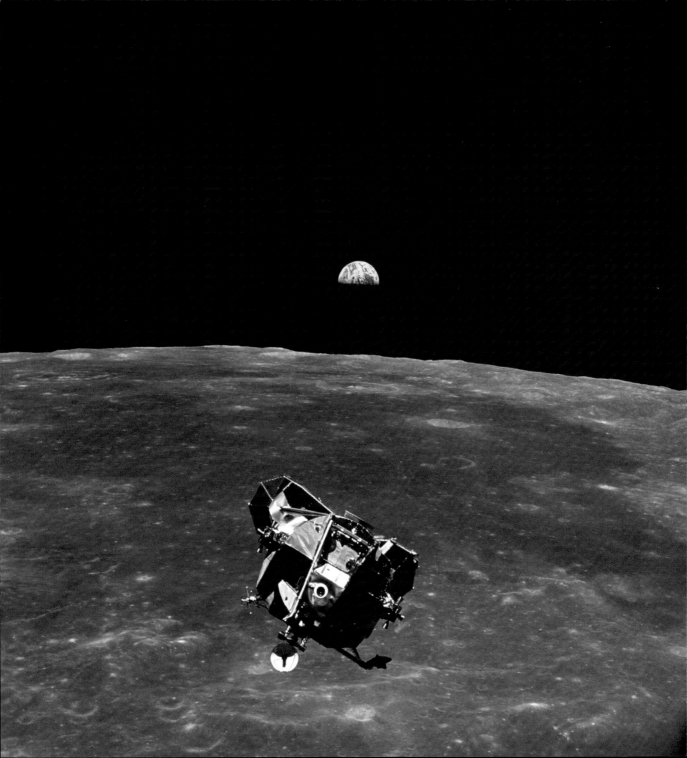

HASSELBLAD & THE MOON LANDING

DEBORAH IRELAND

FOREWORD BY DR MICHAEL PRITCHARD

AMMONITE
PRESS

First published 2018 by
Ammonite Press
an imprint of Guild of Master Craftsman Publications Ltd
Castle Place, 166 High Street, Lewes, East Sussex, BN7 1XU,
United Kingdom

Text © Deborah Ireland, 2018
Foreword © Michael Pritchard, 2018
Copyright in the Work © GMC Publications Ltd, 2018

ISBN 978 1 78145 334 6

A catalogue record for this book is available from
the British Library.

Publisher: Jason Hook
Design Manager: Robin Shields
Designer: Luke Herriott
Editor: Jamie Pumfrey

Colour reproduction by GMC Reprographics
Printed and bound in China

CONTENTS

6 FOREWORD

8 INTRODUCTION

10 HASSELBLAD 500 EL CAMERA

12 MISSION TIMELINE

16 THE CAMERA

18 CAPTURING THE MOON

20 SPACE RACE

22 FIRST HASSELBLAD CAMERA

24 FIRST CIVILIAN HASSELBLAD CAMERAS

26 MERCURY

28 GEMINI

30 LUNA, RANGER, LUNAR ORBITER & SURVEYOR

32 APOLLO 1–10

34 PREPARATION FOR APOLLO 11

36 APOLLO 11 ASTRONAUTS

38 THREE APOLLO 11 HASSELBLADS

40 MISSION CONTROL & CAPCOM

42 TAKE-OFF & LANDING

44 SMALL STEPS & ICONIC IMAGES

46 HASSELBLAD & SCIENTIFIC OBSERVATION

48 PANORAMAS

50 LEAVING THE CAMERAS BEHIND

52 CONSPIRACY THEORIES

54 THE MISSION

92 GLOSSARY & PICTURE CREDITS

93 BIBLIOGRAPHY

94 INDEX

96 ACKNOWLEDGMENTS

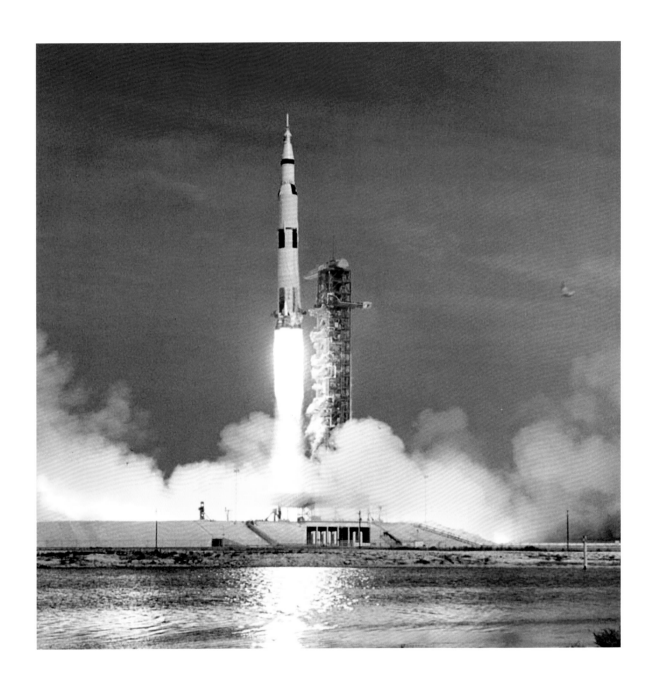

HASSELBLAD & THE MOON LANDING

FOREWORD

When photography was announced in 1839, the camera was firmly rooted to Earth, its people and places. But within a few years, during the 1840s, astronomical photography was born as the Sun, the solar spectrum and the Moon were photographed to support scientific research. As photography evolved, so photographers were able to turn their attention to other phenomena such as eclipses and ever more detailed surveys of the Moon and the heavens.

The years after the Second World War saw the camera and instruments, made to capture the wider electromagnetic spectrum, move off Earth and into space on unmanned rockets and attached to satellites. This was the period that the Hasselblad, too, morphed from being a military tool to the professional camera system that it became in the 1950s.

The Mercury 8 mission of 1962 brought together the Hasselblad camera and manned space flight, transforming space imaging from simply a means of recording science. Giving a man (and it was always a man on NASA flights until 1983) a camera and a human perspective on what and how to photograph,

combined art and science completely. It is unsurprising that the original images from the Apollo missions now sit comfortably in auctions of fine-art photography and in galleries.

This book tells the story of those images, through the cameras and photographers – the astronauts – who made them. Today's digital technology may have changed the method of securing images away from film, but the human element is an intrinsic part of them. The images being returned from today's space missions remain compelling and continue to enthral the public much as those from the Apollo missions did.

Dr Michael Pritchard
Chief Executive, The Royal Photographic Society

< *The Saturn V launch vehicle for the Apollo 11 mission lifting off at 8:32 am on 16 July 1969 from the Kennedy Space Center in Florida.*

INTRODUCTION

Even in today's image-saturated world, the photography from the Apollo 11 mission still has huge impact as a record of the ultimate human adventure. 2019 marks 50 years since Neil Armstrong and Buzz Aldrin first walked on the surface of the Moon, and the square-format pictures they took with their Hasselblad cameras remain a beautiful and powerful reminder of their extraordinary achievement.

This book tells the story of the Moon landing through the lens of the camera that recorded it, and considers the significance of its photographs in our understanding of this most iconic of space journeys. It narrates the story of the giant technological leap required not only to transport and deliver the first two humans to stand on the Moon, but also to successfully capture the images that bear testament to their having done so.

Apollo 11 represented the first opportunity to directly observe scientific phenomena on the lunar surface. The surface and orbital photography served not only to document the first lunar landing and the extravehicular activities of the astronauts, but also to identify scientific areas and experiments for study in future missions.

The photographic equipment and materials carried by Apollo 11 were designed specifically:

1 to photograph 'targets of opportunity,' i.e. scientifically interesting sites and potential Apollo landing sites as time and circumstances permitted;

2 to obtain photographs of the Lunar Module and lunar surface activities after the Lunar Module landing;

3 to obtain vertical and oblique stereo strips of nearside and farside regions of scientific interest;

4 to record mission operational activities;

5 to obtain documentation for subsequent landing crew training purposes.

It was the Hasselblad cameras they carried that enabled the crew members of Apollo 11 to achieve all of their photographic objectives. NASA initially thought that photography could potentially be a distraction and a hazard for astronauts. However, after seeing the images taken by astronaut Wally Schirra, using a Hasselblad, during his Mercury mission in 1962, they were persuaded otherwise. The quality of the images illustrated the story of achievement in space and revealed a view of the world never seen before, which would be invaluable for both science and public relations. From that point onwards, Hasselblads were standard issue on space flights.

The ultimate development was the Hasselblad 500EL Data Camera, which was modified for use on the Moon. Developed in collaboration between NASA, Hasselblad and the lens manufacturer Carl Zeiss, the compact nature of the camera is one of its most remarkable features. The astronauts found it easy to use – even in helmets and gloves – and with it they would achieve their extensive shoot lists and produce some of the most iconic photographs the world has ever seen.

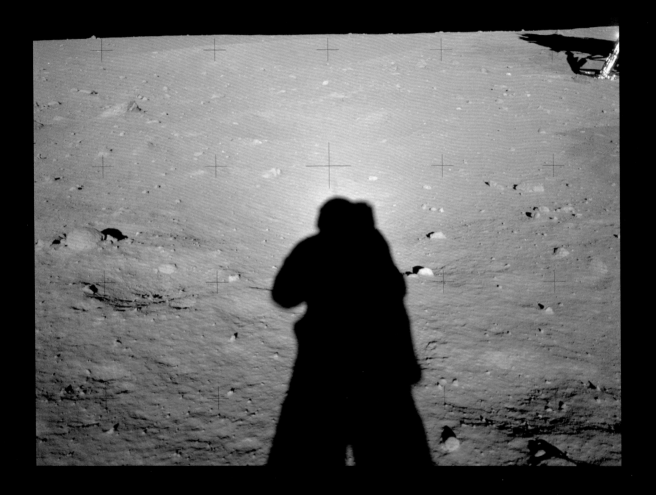

∧ Backlit by the sun, Buzz Aldrin photographs his shadow as it falls on to an alien landscape. In the top-right corner, the Lunar Module sits waiting to return the astronauts to the Command/Service Module.

HASSELBLAD 500EL CAMERA

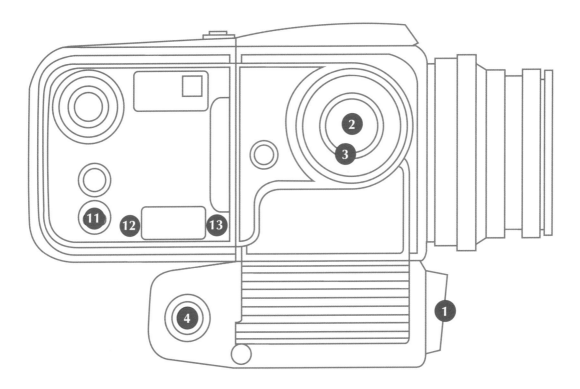

CAMERA CONTROLS

1 Operate Push Button

2 Mode Selector

3 Lens Cocking Tool

4 Remote Connector

5 Battery Compartment

6 Battery Compartment Lock

7 Lens Release Button

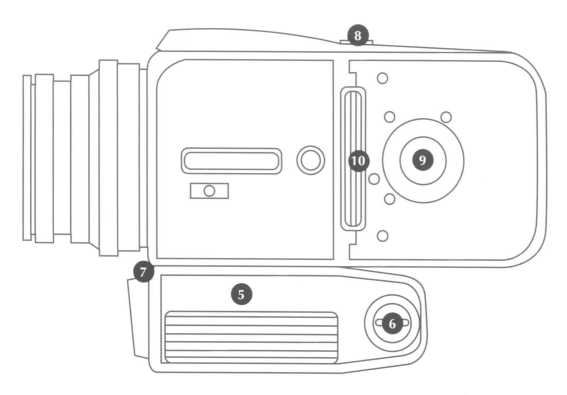

FILM MAGAZINE CONTROLS

8 Magazine Release Button

9 Magazine Insert Lock

10 Darkslide

11 Frame Counter

12 End of Film Indicator

13 Film Advance Indicator

MISSION TIMELINE

MISSION	CREW	CAMERAS & LENSES	PHOTOGRAPHY EXPERIMENTS	OBJECTIVE OF MISSION	COMMENTS
Mercury 3 (Freedom 7) 5 May 1961	Alan Bartlett Shepard Jr.	Maurer model 220G 70mm camera (fixed camera system)	General information photography (more than 150 photographs of sky, clouds and ocean)	Suborbital flight lasting 15 minutes, 22 seconds	
Mercury 4 (Liberty Bell 7) 21 July 1961	Virgil Ivan "Gus" Grissom	Maurer model 220G 70mm camera (fixed camera system)	General information photography	Suborbital flight lasting 15 minutes, 37 seconds	Photography over the Atlantic Ocean, and North and Central Africa
Mercury 6 (Friendship 7) 20 February 1962	John Herschel Glenn Jr.	Ansco Autoset 35mm camera with 55mm lens	General information photography	3 orbits of Earth	48 photographs of clouds, oceans and Northwest Africa
Mercury 7 (Aurora 7) 24 May 1962	Malcolm Scott Carpenter	Robot Recorder 35mm camera with 75mm f/3.5 and 45mm f/2.3 lenses	Selected areas for terrain photography (155 photographs of Earth and Earth's limb)	3 orbits of Earth	
Mercury 8 (Sigma 7) 3 October 1962	Walter Marty "Wally" Schirra Jr.	Hasselblad 500C 70mm camera (NASA modified) with Zeiss Planar 80mm f/2.8 lens	Synoptic terrain photography	6 orbits of Earth	Photography of poor quality due to general overexposure
Mercury 9 (Faith 7) 15–16 May 1963	Leroy Gordon "Gordo" Cooper Jr.	Hasselblad 500C 70mm camera (NASA modified) with Zeiss Planar 80mm f/2.8 lens	Reference list of areas and features to be photographed for synoptic terrain photography	22 orbits of Earth	29 photographs of Earth and cloud features; observations on visibility and colour of Earth's features

MISSION	CREW	CAMERAS & LENSES	PHOTOGRAPHY EXPERIMENTS	OBJECTIVE OF MISSION	COMMENTS
Gemini 3 23 March 1965	Virgil Ivan "Gus" Grissom, John Watts Young	Hasselblad 500C 70mm camera (NASA modified) with Zeiss Planar 80mm f/2.8 lens	General terrain and meteorology information photography	3 orbits of Earth	219 photographs of Earth
Gemini 4 3–7 June 1965	James Alton "Jim" McDivitt, Edward Higgins White II	Hasselblad 500C 70mm camera (NASA modified) with Zeiss Planar 80mm f/2.8 lens; Zeiss Contarex 35mm camera with 250mm lens	Synoptic terrain photography, synoptic weather photography and Earth's limb photography	First space walk and 62 orbits of Earth	
Gemini 5 21–29 August 1965	Leroy Gordon "Gordo" Cooper Jr., Charles "Pete" Conrad Jr.	Hasselblad 500C 70mm camera (NASA modified) with Zeiss Planar 80mm f/2.8 lens; Zeiss Contarex 35mm camera with 250mm lens; Questar 1200mm telescope	Zodiacal light photography, synoptic terrain photography, synoptic weather photography, visual acuity experiment and surface photography	To test the astronauts and capsule for an extended length of time in space and 120 orbits of Earth	250 photographs of Earth
Gemini 6A 15–16 December 1965	Walter Marty "Wally" Schirra Jr., Thomas Patten Stafford	Hasselblad 500C 70mm camera (NASA modified) with Zeiss Planar 80mm f/2.8 lens	Synoptic terrain photography and synoptic weather photography	Rendezvous in orbit with Gemini 7 and 16 orbits of Earth	
Gemini 7 4–18 December 1965	Frank Frederick Borman II, James Arthur Lovell Jr.	Hasselblad 500C 70mm camera (NASA modified) with Zeiss Planar 80mm f/2.8 lens; Zeiss Contarex 35mm camera with 250mm lens	Synoptic terrain photography and synoptic weather photography	Rendezvous in orbit with Gemini 6 and 206 orbits of Earth	429 photographs of Earth

MISSION	CREW	CAMERAS & LENSES	PHOTOGRAPHY EXPERIMENTS	OBJECTIVE OF MISSION	COMMENTS
Gemini 8 16–17 March 1966	Neil Alden Armstrong, David Randolph Scott	Hasselblad 500C 70mm camera (NASA modified) with Zeiss Planar 80mm f/2.8 lens	Zodiacal light photography and synoptic terrain photography	Rendezvous and dock with Agena target vehicle and 7 orbits of Earth	19 photographs of Earth, 1 photograph of Earth's limb, 6 oblique photographs of Earth
Gemini 9A 3–6 June 1966	Thomas Patten Stafford, Eugene Andrew Cernan	Hasselblad 500C 70mm camera (NASA modified) with Zeiss Planar 80mm f/2.8 lens; Hasselblad Super Wide C camera (NASA modified) with Zeiss Biogon 38mm f/4.5 lens; Maurer 70mm camera with Xenotar 80mm f/2.8 lens	Zodiacal light photography, synoptic terrain photography and airglow photography	Test rocket-powered jet pack and 44 orbits of Earth	
Gemini 10 18–21 July 1966	John Watts Young, Michael Collins	Hasselblad Super Wide C camera (NASA modified) with Zeiss Biogon 38mm f/4.5 lens; Maurer 70mm camera with Xenotar 80mm f/2.8 lens	Zodiacal light photography, synoptic terrain photography, synoptic weather photography and UV star field camera experiment	Rendezvous and dock with Agena target vehicle (failed) and 43 orbits of Earth	371 photographs of Earth
Gemini 11 12–15 September 1966	Charles "Pete" Conrad Jr., Richard Francis Gordon Jr.	Hasselblad Super Wide C camera (NASA modified) with Zeiss Biogon 38mm f/4.5 lens; Maurer 70mm camera with Xenotar 80mm f/2.8 lens	Airglow horizon photography, synoptic terrain photography, synoptic weather photography, UV star field camera experiment and lunar UV spectral reflectance	Rendezvous and dock with Agena target vehicle, 2 extravehicular activities (EVA) and 44 orbits of Earth	
Gemini 12 11–15 November 1966	James Arthur Lovell Jr., Edwin Eugene "Buzz" Aldrin Jr.	Hasselblad Super Wide C camera (NASA modified) with Zeiss Biogon 38mm f/4.5 lens; Maurer 70mm camera with Xenotar 80mm f/2.8 lens	Airglow horizon photography, synoptic terrain photography, synoptic weather photography, Earth Moon libration region photography, UV star field camera experiment and sodium cloud photography	Rendezvous and dock with Agena target vehicle, 3 EVAs and 59 orbits of Earth	415 photographs of Earth

MISSION	CREW	CAMERAS & LENSES	PHOTOGRAPHY EXPERIMENTS	OBJECTIVE OF MISSION	COMMENTS
Apollo 7 11–22 October 1968	Walter Marty "Wally" Schirra Jr., Donn Fulton Eisele, Ronnie Walter Cunningham	Hasselblad 500C 70mm camera (NASA modified) with Zeiss Planar 80mm f/2.8 lens	Earth-cloud photography	Demonstrate Command and Service Module performance and 163 orbits of Earth	533 photographs: 35 on black & white film and 498 on colour film
Apollo 8 21–27 December 1968	Frank Frederick Borman II, James Arthur Lovell Jr., William Alison "Bill" Anders	2 x Hasselblad 500EL 70mm camera with Zeiss Planar 80mm f/2.8 lens; Zeiss Sonnar 250mm f/5.6 lens	Photography of lunar surface, particularly far side of the Moon	Leave Earth orbit and travel to the Moon, 2 orbits of Earth and 10 orbits of the Moon	
Apollo 9 3–13 March 1969	James Alton "Jim" McDivitt, David Randolph Scott, Russell Louis "Rusty" Schweickart	2 x Hasselblad 500C 70mm camera (NASA modified) with Zeiss Planar 80mm f/2.8 lens; 4 x Hasselblad 500EL 70mm camera with Zeiss Planar 80mm f/2.8 lens	Multispectral terrain photography	Test of first crewed Lunar Module and 151 orbits of Earth	1,373 photographs: 318 on black & white film, 787 on colour film and 267 on infrared film
Apollo 10 18–26 May 1969	Thomas Patten Stafford, John Watts Young, Eugene Andrew Cernan	2 x Hasselblad 500EL 70mm camera with Zeiss Planar 80mm f/2.8 lens; Zeiss Sonnar 250mm f/5.6 lens	Lunar Module photography and lunar surface photography	Rehearsal for the Moon landing, 2 orbits of Earth and 31 orbits of the Moon	
Apollo 11 16–24 July 1969	Neil Alden Armstrong, Michael Collins, Edwin Eugene "Buzz" Aldrin Jr.	Hasselblad 500EL 70mm camera (Réseau plate) with Biogon 60mm f/5.6 lens; 2 x Hasselblad 500EL 70mm camera with Zeiss Planar 80mm f/2.8 lens	Photography of targets of opportunity, Lunar Module photography and lunar surface activities	Land 2 astronauts on the Moon, 2 orbits of Earth and 30 orbits of the Moon	1,407 photographs: 857 on black & white film and 550 on colour film

THE CAMERA

CAPTURING THE MOON

The night sky was a highly popular subject for early photography, but one that was extremely difficult to capture successfully. Astronomical photographer Warren De la Rue observed that: *"The eye can see minute objects, even while they are moving, but in the photograph the movement produces a more or less blurred image. It is seldom that any object is seen undisturbed in the telescope."*

The solution to this problem came in 1847 from Harvard College Observatory in Cambridge, Massachusetts,

USA, where a telescope was built to track objects in the sky. Commissioned by the director of the observatory, William Cranch Bond, the 'Great Refractor' had an aperture measuring 15in (38cm) and was the second largest telescope of its type.

Bond worked with John Adams Whipple, who was the first person in the USA to manufacture the chemicals needed for the daguerreotype process. By placing a daguerreotype plate within the focus of the telescope, successful images of the night sky, including the Moon,

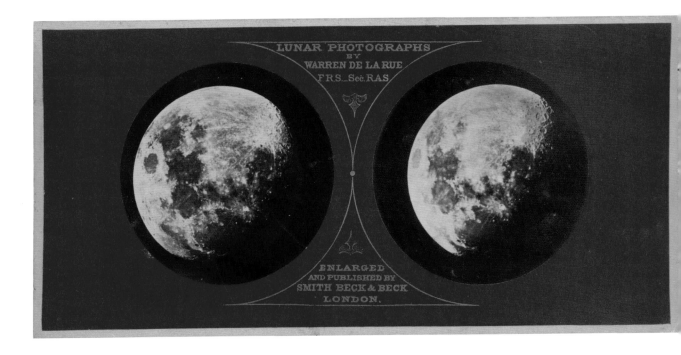

could be captured. One of these early lunar images was exhibited at the Great Exhibition in London, England, in 1851, where it was seen by De la Rue, who was inspired to try lunar photography for himself. Rather than using daguerreotypes, De la Rue employed Frederick Scott Archer's wet collodion process – details of which had just been published in *The Chemist* in March 1851. The advantages over the daguerreotype process were shorter exposure times and the ability to make multiple prints from the resulting glass negatives.

Although he was only an amateur photographer and astronomer, De la Rue created his own observatory with a clockwork-driven telescope, and also built his own 'Moon camera'. The camera, which is now in the Museum of Science at the University of Oxford, England, was of his own design and was more of an attachment to the telescope than a camera in its own right. Through continual improvements to his equipment, De la Rue produced some stunning lunar photographs. Although he started out as an amateur, by the end of his life he was known as the 'father of celestial photography'.

Perhaps the most unusual 19th-century photographs of the Moon were taken by James Nasmyth and appeared in his 1874 book, *The Moon: Considered as a Planet, a World, and a Satellite*. Nasmyth was an engineer, inventor and astronomer, but was famous for having invented the steam hammer. Frustrated by the limitations of photography in capturing the details of the Moon's features that were visible through telescopes, Nasmyth began to create plaster models based on his drawings and observations. He then photographed the models, carefully lighting them to show the craters to their best effect. He also exhibited detailed maps of the Moon at the Great Exhibition of 1851.

The Moon inspired not only photographers but writers, and in Victorian fiction we find the first notion of it as a potential destination for human travel. The authors who sowed the seed of this idea included Jules Verne in his prescient scientific-fiction adventures *From the Earth to the Moon* (1865) and *Trip around the Moon* (1870).

There are remarkable similarities between Verne's novels and the first Moon landing in 1969. His fiction predicted that the USA would be the first country to send a piloted rocket to the Moon (and with a crew of three men), launching from Florida and landing with a splashdown in the Pacific Ocean. Apollo 11's Command/Service Module was named *Columbia*, which is not only the poetic name for America but was also partly inspired by Verne's rocket, *Columbiad*.

< *A pair of stereoscopic albumen prints (84 x 174 mm) of the Moon, taken by Warren De la Rue using the wet collodion process to create negatives. The left-hand print was taken on 27 August 1860 and the right-hand print on 5 December 1859.*

SPACE RACE

In 1954, the International Council for Scientific Unions, a non-government organization comprising 67 countries, called for artificial satellites to be launched during the International Geophysical Year (IGY). The IGY was a high point of sunspot activity (solar cycle 19) that ran from 1 July 1957 to 31 December 1958. In response, the White House made a formal statement that the USA would contribute a satellite programme, but the proposed September 1957 launch of its Vanguard rocket was delayed. This enabled the Soviet Union to successfully launch the world's first satellite, Sputnik 1, into space.

Sputnik 1 (whose name translates as 'fellow traveller') was launched on 4 October 1957, an event that marked the start of the Space Age. With a diameter of just 23in (58cm), Sputnik 1 was the size of a beach ball and orbited Earth in 98 minutes. Less than a month later, on 3 November 1957, the Soviets successfully launched Sputnik 2. On board was a dog named Laika – the first animal in space.

Politically, the Cold War was raging between East and West, and with the Soviet Union winning the space race it was feared that the USA was falling behind in terms of technological advancement. In direct response to this, the National Aeronautics and Space Administration (NASA) was formed on 29 July 1958. On 31 January 1961, the American Mercury-Redstone flight MR-2 carried the first hominid into space – a chimpanzee called Ham. More importantly, unlike Laika, Ham was returned safely to Earth.

The USA's triumph was short-lived when Yuri Gagarin became the first human in space in Vostok-1 on 12 April 1961, gaining instant international celebrity. Just 23 days later, on 5 May 1961, Alan Shepard became the first American in space when he made a short suborbital flight in the Mercury Freedom 7 capsule launched by a Redstone booster. Soon after, on 25 May 1961, President John F. Kennedy made a speech to Congress, calling for funding to put the first human on the Moon before the end of the decade.

Key dates

4 October 1957: Sputnik 1, first satellite in space (USSR)
3 November 1957: Sputnik 2, Laika, first animal in space (USSR)
31 January 1961: MR-2, Ham, first hominid in space (USA)
12 April 1961: Vostok-1, Yuri Gagarin, first human in space (USSR)
6 August 1961: Gherman Titov, second human to orbit Earth (USSR)
16 June 1963: Valentina Tereshkova, first woman in space (USSR)
18 March 1965: Alexei Leonov, first spacewalk (USSR)

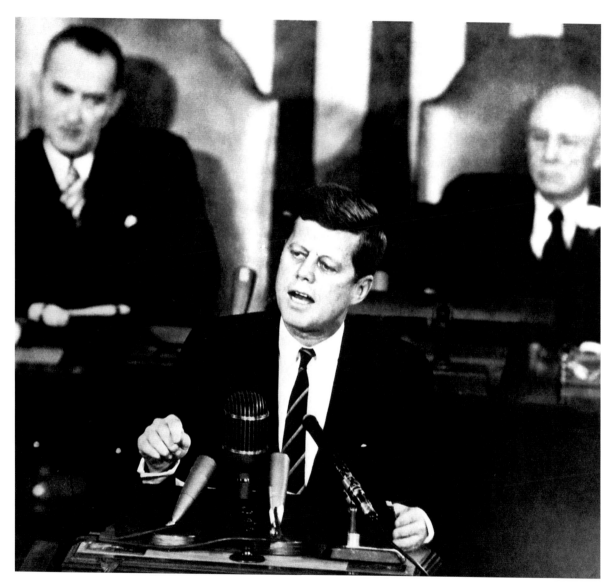

∧ *"First, I believe that this nation should commit itself to achieving the goal, before this decade is out, of landing a man on the Moon and returning him safely to the Earth. No single space project in this period will be more impressive to mankind, or more important for the long-range exploration of space; and none will be so difficult or expensive to accomplish." —John F. Kennedy, 25 May 1961*

FIRST HASSELBLAD CAMERA

It seems entirely fitting that the origins of the Hasselblad camera used in space can be traced back to an aerial camera used by Swedish Air Force crews for surveillance. F. W. Hasselblad and Co., founded in 1841, was a trading company that imported goods into Sweden. By 1893, the company was selling a wide range of photographic-related goods, including Eastman Kodak products, and had published its first photographic equipment catalogue.

The creator of the first Hasselblad camera was Victor Hasselblad (1906–78), a keen ornithologist who enjoyed photographing birds in their natural habitats. In preparation for working in the family business,

he was sent to gain experience at Kodak Pathé in France, Zeiss in Germany and Eastman Kodak Co. in the USA. The knowledge gained from his wide-ranging apprenticeship would prove invaluable in later years.

During the Second World War, Sweden maintained neutrality, but the country mobilized. The Royal Swedish Air Force needed aerial cameras to maintain surveillance of the country's borders, so photographic experts at the air force headquarters contacted Victor Hasselblad: *I received an inquiry – 'Can you make a camera like this?' And they showed me a captured German camera. I inspected it closely and saw that it wasn't anything very special. So, I replied truthfully: 'No, I cannot make one like that, but I can make one better.'*

Hasselblad received the air force contract in April 1940 and immediately set up a workshop and found a machinist, Ake Tranefors, to work with him. Together they produced a prototype that would become the HK7, a relatively lightweight (8.4lb/3.8kg) handheld camera that used 80mm perforated film and had three interchangeable lenses: a Zeiss Biotessar 13.5cm f/2.8, a Meyer Tele-Megor 25cm f/5.5 and a Schneider Tele-Xenar 24cm f/4.5. The company made 240 HK7 cameras between 1940 and 1943.

The success of the HK7 led the Swedish Air Force to commission a second camera in 1941. This time, it wanted a larger camera that could be mounted in an

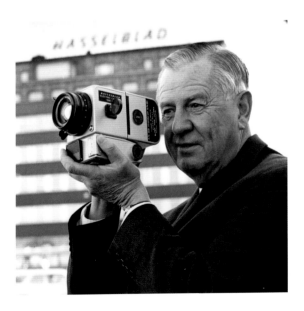

< *Victor Hasselblad with the Hasselblad 500EL camera.*

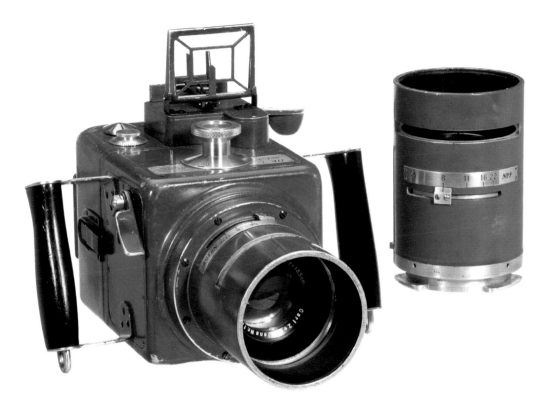

∧ *The HK7 camera was the first Hasselblad camera and was produced between 1940 and 1945.*

observation plane. The resulting model – the SKa4 – had important features that would appear in later Hasselblad cameras designed for the civilian market, including interchangeable film magazines and powered film advance. In total, 70 cameras were produced, with the factory also assisting in the manufacture of equipment to process aerial film.

By the end of 1943, Hasselblad employed 45 highly skilled precision-tool makers who were engaged in fulfilling contracts for the Swedish government. Although the war was still raging, Victor Hasselblad had already started to plan for the post-war years when he could make cameras for civilian use. For his plans to succeed, it was vital that he kept his skilled workforce together. So, he took on subcontracting work, producing precision gears for SAAB, the military aircraft manufacturer, as well as for clocks and slide projectors. It was during this time that design work began on the Hasselblad 1600F camera.

FIRST CIVILIAN HASSELBLAD CAMERAS

Victor Hasselblad's wartime aerial cameras had interchangeable lenses and film magazines, features that he wanted to apply to 'the civilian camera'. The final design of the camera was decided by competition, with a prize of 5,000 kronor (approximately one year's pay for a skilled worker) shared among the Hasselblad employees who contributed to the winning design.

Sixten Sason, a Swedish industrial designer, gave the final camera design a sleek look. The result was the Hasselblad 1600F: a small, compact, single-lens reflex camera. The body dimensions were a mere 4⅞ x 3½ x 3½in (12.4 x 8.9 x 8.9cm) and, with a standard Kodak lens, the camera weighed just 2lbs 12oz (1.1kg).

The factory's production methods had to be changed completely to manufacture the 1600F, with precision milling machines replacing hand tools. The critical response made all the effort worthwhile and the camera was distributed in the USA by Willoughby's, with a retail price of $570, which included one lens and a film magazine. There were a few glitches with the first model – the shutter speed was problematic – but this didn't prevent well-known photographers such as Ansel Adams offering to test the camera. Hasselblad was able to use the images Adams took in advertising campaigns, and his feedback on the camera's performance contributed to the Hasselblad 1000F that became available in 1952.

HASSELBLAD EVOLUTION

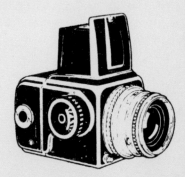

∧ *1600F (1948)* ∧ *1000F (1952)* ∧ *500C (1957)*

For professional photographers – particularly those working in the design and fashion world – the Hasselblad would become an essential camera. The work of fashion photographer John French perhaps best illustrates how this one camera revolutionized the use of photographs in newsprint. Before the 1950s, drawings were often used in newspapers to illustrate fashion because photographs 'sooted up' and became unreadable on the page. However, in 1950 the UK's *Daily Express* newspaper allowed French to use a soft, high-key photograph taken on a Hasselblad of the model Barbara Goalen in an evening dress. Every detail of the dress was revealed on the newspaper cover and the photograph was a great success.

On 11 November 1955, in an article in the *Daily Express* called *The Hasselblad Eye*, John French himself explained the camera's importance: *"Because this page has always pioneered the best in fashion photography I want you to know about this big step forward. Study the picture on the left; it marks a startling step forward in the techniques of photography. Right in the foreground the photographer's own hand is in focus. In perfect focus too the girl in the swirling coat. Equally in focus the man from Mayfair way behind. If this were a studio picture taken with elaborate lights and equipment it would be nothing unusual, but shot at speed in open air with a camera smaller than the bowler hat in the background it is very exceptional indeed."*

∧ *500EL (1965)*

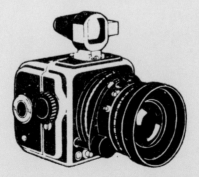

∧ *Super Wide (1954)*

∧ *Super Wide C (1959)*

MERCURY

NASA's Project Mercury was the first human spaceflight programme of the USA and it had three objectives:
- to orbit a piloted spacecraft around Earth;
- to investigate human ability to function in space;
- to recover the astronauts and their spacecraft safely.

Lasting nearly five years, from 1958 to 1963, the project achieved six piloted flights and all of its goals.

From 110 candidates, seven test pilots were chosen to become the first 'astronauts'. They became known as the Mercury Seven. One of them, Wally Schirra, wrote: *"Seven men – all super achievers with super egos – came together to work as a team. We had total faith in one another..."*

Project Mercury was so complex that the astronauts decided to assign responsibility for particular parts of the programme to individuals. If there were a problem they would call a subject-specific meeting, which enabled them to see the project as a whole and contribute to engineering decisions at a detailed level. This research-led approach had huge implications for photography on the missions, leading directly to the inclusion of a camera and a window in the capsule.

V *The first Hasselblad in space: the 500C camera body, film magazine and Zeiss lens used by Wally Schirra and Gordon Cooper.*

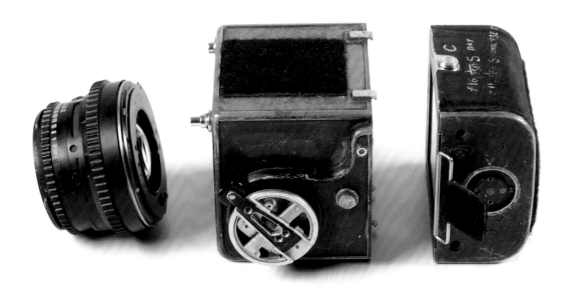

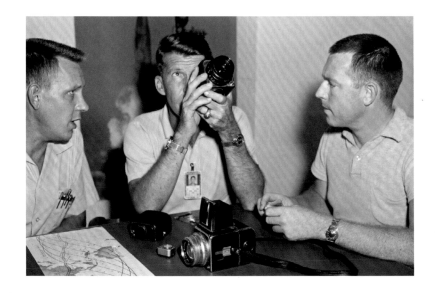

< Wally Schirra examines the Hasselblad camera alongside Gordon Cooper (left) and Roland Williams (right).

Engineers had already included a periscope with a wide-angle lens as part of the original design, but it distorted the view. This made it impossible to navigate by the stars, see Earth from space or (importantly for the future) rendezvous and dock with another spacecraft. Wally Schirra commented: *"The eyeball was not being optimized, as we like to say in engineering language."* By the time the second suborbital flight took place on 21 July 1961, the spacecraft had a window.

In January 1962, another of the Mercury Seven, John Glenn, was trying to persuade NASA to let him take a camera into space. NASA did not have a camera section and initially considered the exercise a distraction, but Glenn persisted until they agreed. He tried both a Leica and a Minolta camera before settling on the latter, which was the easiest to use while wearing his pressure gloves. On 20 February, Glenn orbited Earth in Friendship 7, as part of the Mercury 6 mission, with his Minolta. The images he took captured for the first time the beauty of Earth as seen from space.

Wally Schirra decided that a Hasselblad 500C, with its larger film frame (2¼ x 2¼in/6 x 6cm), was more suitable than a 35mm camera for his flight on Sigma 7, which launched on 3 October 1962. Taking the 'approach of an engineer rather than a sightseer', he consulted *National Geographic* photographers Dean Conger and Luis Marden (a pioneer in colour photography), and *Life's* Ralph Morse and Carl Mydans.

After the success of Schirra's mission – and his photography – a Hasselblad was included on all future space flights. Schirra immersed himself in the camera, learning how to take it apart and repair it. This would prove invaluable on the Apollo 7 mission, when the camera jammed and he was able to fix it with a speck of petroleum-based ointment from the medicine kit.

GEMINI

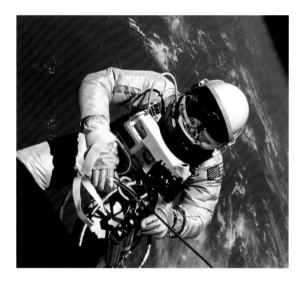

∧ *Astronaut Edward H. White II, pilot of Gemini 4, floats in zero gravity outside his spacecraft.*

After the success of Project Mercury, NASA moved forward with Project Gemini. Gemini was an earth-orbiting programme, designed to test the equipment and skills needed by astronauts and ground crew to land a human successfully on the Moon. Its goals included walking in space, changing orbit, the rendezvous and docking of two spacecraft and keeping a crew of two astronauts healthy in space for a prolonged period of time. The programme would succeed in achieving all of these goals.

The Hasselblad 500C was again the camera of choice for the Gemini missions and enabled the astronauts to record what they saw. What is perhaps most remarkable is

how the first Hasselblads in space worked so well with very little modification. They used Zeiss lenses and had features such as film magazines that could be changed mid-roll when the light conditions altered. Schirra removed the leatherette covering and painted the camera black to reduce reflections. Outside the spacecraft, the cameras performed reliably in temperatures varying from more than 250°F (120°C) in the sun to -85°F (-65°C) in the shade.

Some of the most dramatic images from this period were of Ed White undertaking his first 'spacewalk'. The photographs were taken by James A. McDivitt, commander of Gemini 4, who described the EVA (extravehicular activity) as the most dangerous thing he experienced in space. The hatch gearing mechanism had already proved problematic on Earth when the capsule was tested, but in space it would not close and McDivitt had to work in the dark wearing thick gloves to get the gears together before he could close the hatch.

Despite the difficulties, the public saw a successful mission, with photographs of White's exuberant walk in space reproduced around the world, in *Stern*, *Time* and on the cover of *Life* magazine, along with a 16-page colour feature. It was obvious that high-quality images were very important to the space programme.

In Sweden, Hasselblad also saw the pictures of White's spacewalk and realized they had been taken with one of its cameras. Hasselblad contacted NASA and offered to develop a camera for use in space. The two would work together from that moment on until 2003.

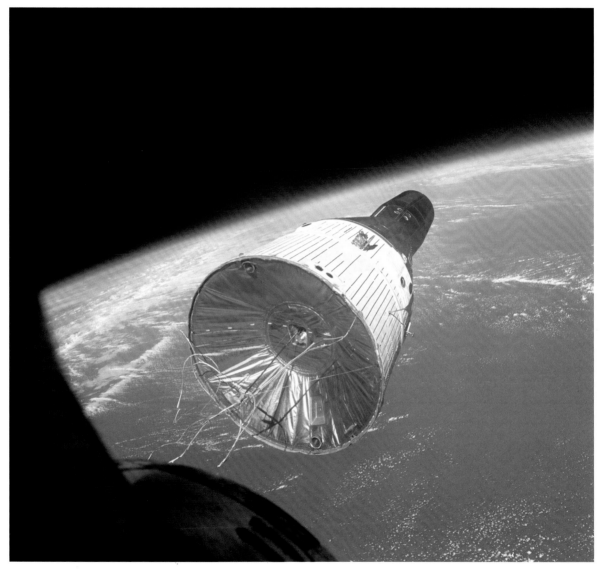

∧ *Taken by Gemini 7 crew members Jim Lovell and Frank Borman, this photograph shows Gemini 6A in orbit 160 miles (257km) above Earth.*

LUNA, RANGER, LUNAR ORBITER & SURVEYOR

From 1957, both the USA and Soviet Union launched unpiloted space probes to the Moon. The Soviet Luna programme ran from 1959 to 1976, during which time it achieved an impressive number of firsts: Luna 1 (1959) became the first spacecraft to escape geocentric orbit; Luna 2 (1959) became the first human-made object to reach the Moon; and Luna 3 (1959) became the first spacecraft to record photographic images of the far side of the Moon.

On 3 February 1966, British scientist John Grant Davies observed Luna 9 when it became the first spacecraft to land safely on the Moon and send back images. Davies was tracking the probe with the Mark-1 radio telescope (renamed the Lovell Telescope in 1987) at Jodrell Bank, England, when he noticed the radio signals it was transmitting had changed to facsimile transmissions. The *Daily Express* newspaper sent a Muirhead facsimile converter to Jodrell Bank, enabling

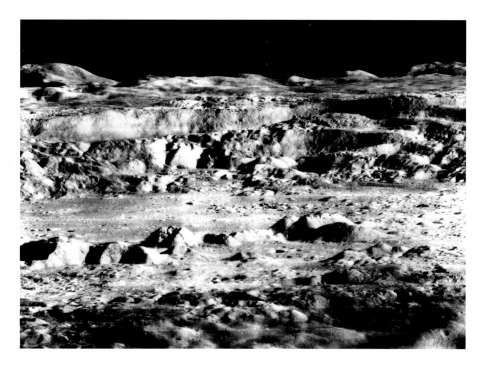

< *Taken by Lunar Orbiter 2 on 24 November 1966, the photograph of the dramatic landscape of the Copernicus lunar crater was described by* Life *magazine as the "Picture of the Century".*

Davies to capture the first photographs of the Moon's surface as they were sent back. Before the Soviets had even announced their success in taking photographs of the Moon's surface, the British newspaper had it on the front page.

NASA's own lunar probes – Ranger, Lunar Orbiter and Surveyor – carried automated film-processing laboratories, so images taken by the probes could be developed and scanned on board the spacecraft and then sent back to Earth by radio transmission. The solar-powered Ranger probes were designed to crash into the Moon, sending back images until the moment of impact. The first Ranger probe was sent on 23 August 1961, but it was not until Ranger 7 in 1964 that the first images of the Moon were transmitted to Earth. Ranger 7 sent back more than 4,300 photographs from six cameras, providing detailed information about the Moon's surface. Craters of all sizes were the dominant feature, even in areas that appeared smooth and flat when viewed through terrestrial telescopes.

Five Lunar Orbiter missions were launched between 1966 and 1967, all of which were successful. Their greatest achievement was to photograph and map 99% of the Moon's surface with a resolution of 195ft (60m). The landscape of the Moon was brought to life by an oblique angle view of the crater Copernicus taken on 24 November 1966 by Orbiter 2, from approximately 27 miles (44km) above the surface. The image revealed the peaks and rugged walls of the 50-mile (80-km) diameter impact crater.

The information from the Lunar Orbiter missions was key to the success of the Moon landings, as it helped

∧ *On 31 July 1964, Ranger 7 approached the Moon precisely on target and transmitted 4,316 images in the 15 minutes before it impacted the lunar surface on the northern rim of the Sea of Clouds.*

to identify suitable landing sites. Unlike the Ranger and Lunar Orbiter probes, which crash-landed on completing their missions, the Surveyor craft were designed to land softly on the Moon. As well as taking photographs, they tested the dust depth and the composition of the Moon's surface. Five of the seven Surveyor missions were successful, but of all the probes, only Surveyor 6 (November 1967) was planned to lift-off from the Moon, as well as land on it.

APOLLO 1–10

NASA's third human spaceflight programme, Apollo, had goals that went beyond just landing a human on the Moon and returning them safely to Earth. They also included establishing the technology to meet other national interests in space, achieving pre-eminence in space for the USA, carrying out a programme of scientific exploration of the Moon and developing the capability of humans to work in the lunar environment.

On 27 January 1967, NASA had its first space disaster when astronauts Gus Grissom, Edward White and Roger Chaffee lost their lives in a fire during pre-flight tests in the Command/Service Module of Apollo 1. There were problems with the module and substantial pressure to stay on schedule. Space flights were made safer as a direct consequence of the Apollo 1 disaster. Following an investigation, several changes were implemented. The capsule's hatch was modified to open outwards. A mix of oxygen and nitrogen was used in the cabin during pre-launch tests, rather than 100% pressurized oxygen. The nylon spacesuits were replaced with non-flammable cloth, and other flammable materials in the capsule were removed. A new focus on quality control and safety protocol was also introduced.

The next crewed flight would be Apollo 7, which was commanded by Wally Schirra and had a duration of 11 days to test the new Command/Service Module. During the flight, Schirra took many pictures with a Hasselblad 500C, including shots of the Himalayas; he later learned that some of his images were used by the Indian government to help search for water resources.

The next mission, Apollo 8, left Earth's orbit and passed behind the Moon. The crew were the first to photograph Earth from deep space. 'Earthrise', the image described as *"the most influential environmental photograph ever taken"*, was shot on 24 December 1968 by Bill Anders with a Hasselblad 500EL camera. The 500EL automated the picture-taking process. While focus, aperture and shutter speed were set by the astronauts, the camera automatically wound the film and readied the shutter for the next shot. Additional modifications were made to the Hasselblad 500EL to facilitate its use while wearing pressurized suits and gloves.

During the ten-day Apollo 9 mission, the Lunar Module was tested in low-Earth orbit as a self-sufficient spacecraft, performing active rendezvous and docking manoeuvres. The crew returned with remarkable photography, especially of the EVAs, including one of David Scott wearing a distinctive red helmet as he is about to leave the Command/Service Module.

The completion of the Apollo 10 flight in May 1969 marked a Herculean achievement. What had started with the tragedy of Apollo 1 ended with Apollo 10 descending to within nine miles of the Moon's surface. The Hasselblad, of course, was there to document it.

> *Clockwise from top left: View over the Himalayas, taken by Wally Schirra during Apollo 7; Earthrise, taken by Bill Anders during Apollo 8; Apollo 9 EVAs, taken by lunar module pilot Russell L. Schweickart; Farside of the Moon, photographed from the Command/Service Module during Apollo 10.*

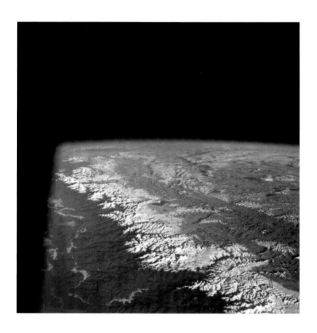

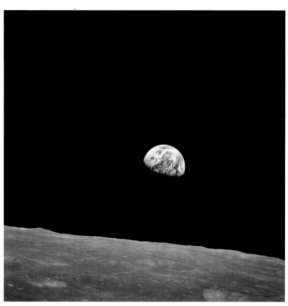

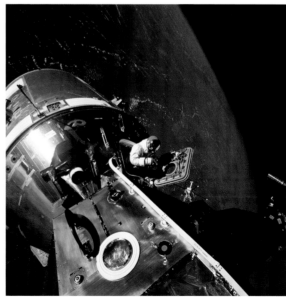

PREPARATION FOR APOLLO 11

During the planning of the Apollo programme, Hasselblad was approached to design a camera that could be used on the Moon and a special development section was established in the factory at Gothenburg to work with NASA. After the fire on Apollo 1 there were tighter safety requirements for all materials used in the space capsules. This included the cameras, which would have to perform to rigorous standards. Zeiss, the lens manufacturer, ran tests to investigate how optics would perform in a vacuum. Hasselblad had to solve the problem of lubricating moving parts, particularly the shutter, as lubricants would boil in a vacuum and leave residue that might affect the mechanism or condense on the lens. Any component that could potentially cause a spark also had to be eliminated.

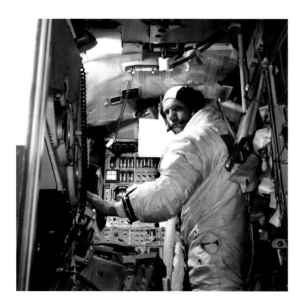

Jack Schmitt, a geologist who had worked on the US Geographical Survey, helped prepare the astronauts for their collecting of rock samples. This was one of the key tasks to be performed on the surface of the Moon, but it was difficult to predict how much time the astronauts would be able to spend on it. Because of the lunar surface temperature variation (180°F/82°C in the sun and -160°F/-106°C degrees in the shade) water was required to cool their suits as they worked, so the time available would be dependent on how long the water supplies lasted.

In Building 9 at Johnson Space Center, Houston, USA, an indoor replica of the lunar landing site was built for Buzz Aldrin and Neil Armstrong to practice their lunar surface work. They were fully suited and wearing extravehicular mobility units (EMUs). Each piece of equipment and procedure had to be tested, rehearsed and timed, and this included the photography. By this stage, the astronauts had learned how to use a Hasselblad 500EL, sometimes employing it with a chest fixing. As there was no viewfinder, it was very much a case of point and shoot.

Intensive training was essential for the whole NASA team, and the staff at Mission Control also participated in flight simulation runs with the Apollo astronauts and their back-up crew. From mid-January to mid-July 1969 the three Apollo 11 astronauts – Aldrin, Armstrong and Michael Collins – trained for a total of 3,521 hours, on top of all the extensive reading, studying and paperwork that was required for their briefing.

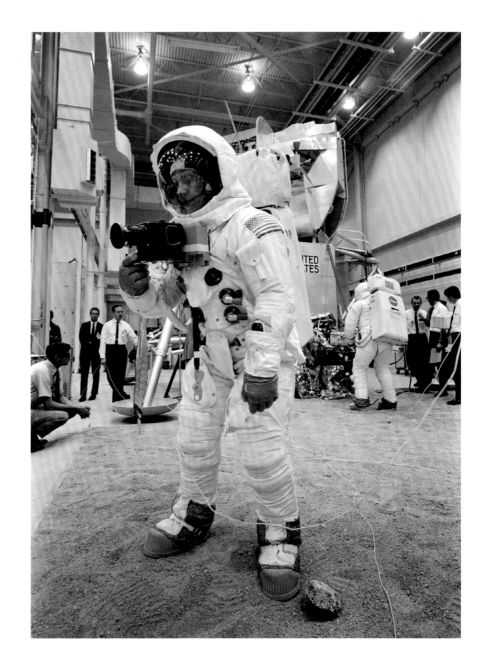

< Neil Armstrong in a Lunar Module simulator in the Flight Crew Training Building at the Kennedy Space Center, Florida.

> Buzz Aldrin uses a triggerless Hasselblad camera during EVA training. In the background, Neil Armstrong can be seen working at the Lunar Module.

APOLLO 11 ASTRONAUTS

Training in flight simulators was critical to the Apollo 11 mission's success. The Command/Service Module and the Lunar Module each had separate simulators. While it was impossible to completely replicate the space environment and spacecraft, this at least gave the astronauts the opportunity to practise flying these complex machines.

Neil Armstrong and Buzz Aldrin worked together to solve problems, trying out ideas in the simulator and giving feedback via Charlie Duke to the flight officers and engineers. Michael Collins worked directly with the Flight Dynamics team. At the end of their intensive period of training, the Apollo 11 crew was fully prepared for the challenge ahead.

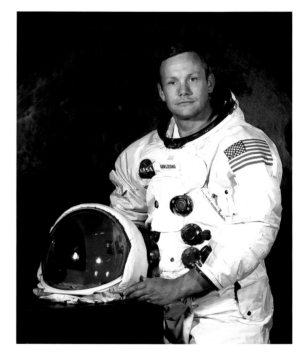

Neil Alden Armstrong
(5 August 1930–25 August 2012)

Neil Armstrong gained his pilot's license at the age of 16 and studied Aeronautical Engineering at Purdue University, Indiana, USA. Under the Holloway Plan, Armstrong's tuition fees were covered in exchange for service in the US Navy. By the age of 20 he was assigned to the VF-51 'Screaming Eagles' fighter squadron and flew 78 missions during the Korean War and went on to join the National Advisory Committee for Aeronautics (NACA). In 1955, he became a research pilot at NASA's Flight Research Center in Edwards Air Force Base, California, before transferring to the astronaut programme in 1962 as part of the second group of NASA astronauts. Armstrong was the commander on Gemini 8 and Apollo 11.

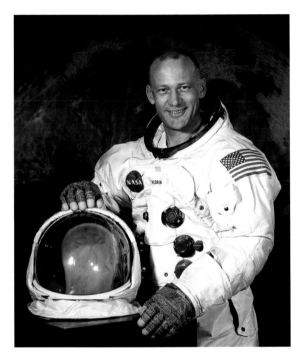

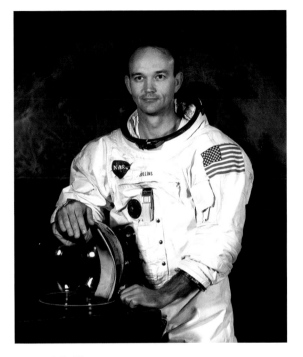

Edwin Eugene "Buzz" Aldrin Jr.

(20 January 1930–)

Buzz Aldrin studied Mechanical Engineering at West Point Military Academy, New York, USA. He joined the Air Force and served in the Korean War, flying 66 missions. In 1955, he graduated from Squadron Officer School at Maxwell Air Force Base in Alabama, and was stationed in West Germany. In 1963, he was awarded a doctorate in Astronautics from the Massachusetts Institute of Technology. Assigned to the Air Force Space Systems Division, he applied to join the Astronauts Corp., but was initially turned down as he was not a test pilot. After this condition was lifted, he was selected for the astronaut programme in October 1963. Aldrin was the pilot on Gemini 12 and the Lunar Module pilot on Apollo 11.

Michael Collins

(31 October 1930–)

In 1952, Michael Collins received a Bachelor of Science degree from the US Military Academy at West Point, New York, USA. He then joined the Air Force and served both as a fighter pilot and as an experimental test pilot at the Air Force Flight Center, Edwards Air Force Base, California. Collins applied for the astronaut programme after being inspired by John Glenn's flight in 1962, but was not successful with his first application. In 1963, while working at Randolph Air Force Base, Texas, Deke Slayton, NASA's Director of Flight Crew Operations, called him to ask if he was still interested in becoming an astronaut. Collins was the pilot on Gemini 10 and the Command/Service Module pilot on Apollo 11.

THREE APOLLO 11 HASSELBLADS

Three Hasselblad 500EL cameras were taken on board Apollo 11. Two of these were conventional cameras, modified for the astronauts' use and fitted with Zeiss Planar 80mm f/2.8 lenses. One of these remained in the Command/Service Module throughout the flight, along with a 250mm telephoto lens and two additional film magazines. The other, along with two more spare magazines, was kept in the Lunar Module. Both of these cameras were for use within the spacecraft.

The third Hasselblad, also in the Lunar Module, was a 500EL Data Camera, which had been modified for use on the Moon's surface and differed from the other two cameras in several ways. The most obvious difference was the silver finish on the body and film magazine, which was designed to help keep internal temperature fluctuations to a minimum.

The Data Camera was fitted with a Réseau plate, a piece of glass with small hairline crosses engraved on its surface. These crosses are a means of determining distances between objects within an image, and they appear on all the pictures taken on the lunar surface. The Réseau plate was not a new invention and had been used in large-format aerial photography cameras, but for space photography it created a potential problem. When the film was wound on it built up static electricity. In a conventional Hasselblad camera, this static was dispersed harmlessly by the metal in the film transport guides and rollers. In the Data Camera, though, the addition of the non-conductive glass Réseau plate meant that static could build up, and the increased potential for sparks would be a fire hazard in a pure oxygen environment. The solution was to apply an extremely thin conductive layer to the side of the plate facing the film to conduct the static safely to the metal parts of the camera.

Hasselblad, in collaboration with Carl Zeiss, designed a lens specifically for NASA that would work with the Réseau plate: a Zeiss Biogon 60mm f/5.6 that was carefully calibrated to ensure the highest quality images with very low distortion.

The interchangeable film magazines on Hasselblad cameras were essential for ease of handling in space, but the standard magazines were designed for 120-format film, which had a paper backing and produced just twelve 2¼ x 2¼in (60 x 60mm) frames. NASA had the backs adapted to accommodate 70mm film. This was still under development at Hasselblad and the first commercially available magazines could only hold approximately 18ft (5.5m) of film, permitting 70 exposures on the available stock. Film manufacturers were developing a thin polyester base for colour film and eventually the magazine would be able to hold 38–42ft (11.5–13m) of film, which was enough for some 200 exposures.

Another important development was the chest fixing. This held the Data Camera in the operating position on the astronaut's chest, allowing him to undertake tasks on the lunar surface while easily taking photographs from a convenient, stable position.

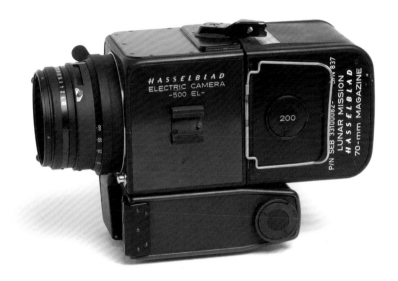

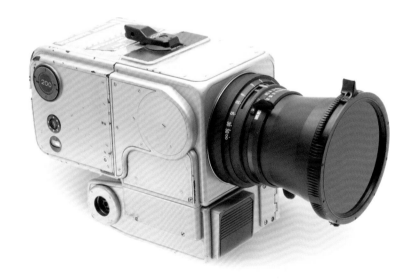

> Top: The Hasselblad 500EL, two of which were taken on the Apollo 11 mission. Bottom: The Hasselblad 500EL Data Camera. This camera was modified for use on the lunar surface.

MISSION CONTROL & CAPCOM

The development of the Mission Control centre, where the Flight Control team could carry out vital support work for the astronauts, was essential to the success of the Moon landing. Work began on a new control centre at Johnson Space Center, Houston, Texas, in 1962.

As technology moved from analogue to digital there was a realization that systems would need to evolve with the project and by 16 July 1969, when the launch of Apollo 11 took place, the mission operations resources had changed considerably. Data was accessible on-screen, served by large networks of mainframe computers, with engineers and officers monitoring and providing support in key areas. The experience and knowledge gained from the Apollo programme would form the basis of the future of modern computing.

Housed in Building 30 at Johnson Space Center, Mission Control was a large room, divided in two, with an operations area at the front and a glass-fronted viewing room that provided seating for 74 visitors at the back. The operations area had four rows of console desks with display screens, tiered like an auditorium, with the focus on the large display and projection screens on the front wall. The consoles at the front of the room were known as the 'trench' and were occupied by the Flight Dynamics team, led by the Flight Dynamics Officer, or 'FIDO'.

Another important role was that of the CAPCOM (CAPsule COMmunicator), who was the only member of the Mission Control team that communicated directly with the crew in space. This role was always taken by an astronaut, as it was felt they were best placed to understand exactly what the crews were experiencing and how best to communicate with them. Buzz Aldrin summarized this relationship:

"All the information that we needed to know from the many monitors in Mission Control, and feedback on what we were experiencing in space, flowed through the CAPCOM."

During the Apollo 11 mission, 11 astronauts undertook the role of the CAPCOM, working in shifts. For the Moon landing itself, Charlie Duke was the CAPCOM, while the CAPCOM for the extravehicular activity (EVA) was Bruce McCandless. Part of McCandless's role was to prompt the astronauts on their activities, including the photography they were to undertake. He could see the astronauts at work via the television cameras transmitting to one of the wall screens at Mission Control, and he would often advise Armstrong and Aldrin to pick up the Hasselblad.

The EVA phase lasted for approximately two-and-a-half hours, so the CAPCOM played a very important part in maximizing the use of time on the Moon's surface, even introducing the President via a live phone call from the Oval Office in the White House.

> *Top: The CAPCOM at Johnson Space Center, Houston. Bottom: The Launch Control team at Kennedy Space Center, Florida.*

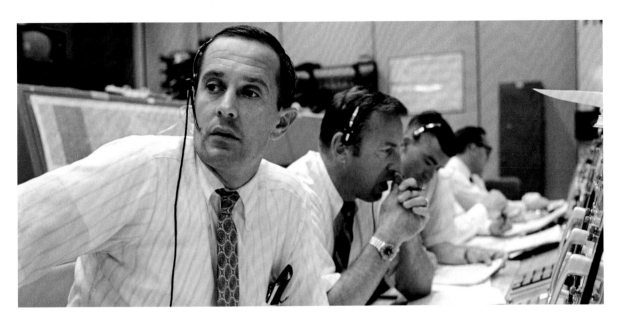

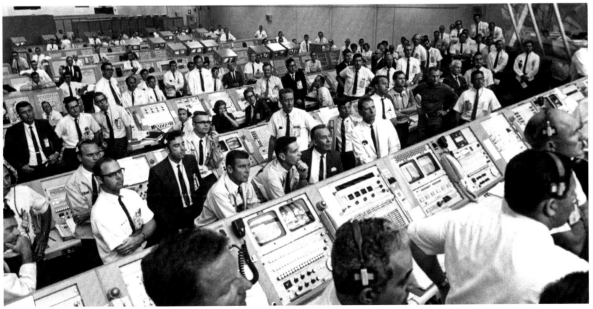

TAKE-OFF & LANDING

The Saturn V launch vehicle for the Apollo 11 mission lifted off from Cape Kennedy, Florida, on 16 July 1969 at 9.32 a.m., powered by 2,000 tons of liquid oxygen, liquid hydrogen and kerosene propellants. After two hours and 44 minutes, Michael Collins ignited Saturn V's third-stage rocket engines to take Apollo 11 out of Earth's orbit and towards the Moon.

Buzz Aldrin very clearly describes the next stage: *"The burn was successful, so it was time to let go of the third-stage rocket. But we first needed to extract the Lunar Module (LM) that had been stored in the third stage, now fully exposed as the protective panels were released. We detached the Command Module (CM) to move forward and away from the rocket, and then navigated a full U-turn to head back towards the LM. Mike adeptly docked the nose of the CM to the nose of the LM, just as he had done hundreds of times in simulations."*

It would take three days to reach the Moon, and two further burns to achieve lunar orbit. Nothing could have prepared the crew for the view of the Moon at such close proximity. Collins would describe it as: *"a formidable presence without sound or motion."* He later commented: *"The first thing that springs to mind is the vivid contrast between Earth and the Moon. One has to see the second planet up close to truly appreciate the first. I'm sure that to a geologist the Moon is a fascinating place, but the monotonous rock pile, this withered, sun-seared peach pit out of my window offers absolutely no competition to the gem it orbits."*

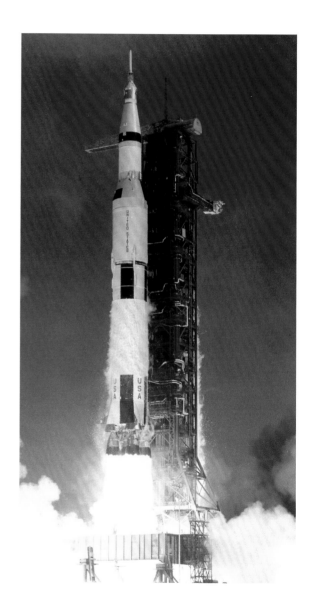

On 20 July, the crew suited up in preparation for the separation of the Command/Service and Lunar Modules. There was little room for the three men to do this, but finally the hatch was sealed on each side. After 100 hours and 12 minutes of the flight, the Lunar Module *Eagle* carrying Armstrong and Aldrin undocked and separated from the Command/Service Module *Columbia*. Collins visually checked *Eagle* for damage – especially the landing gear – and took a series of pictures with the Hasselblad as Armstrong turned a full rotation and tumbled away into space.

Eagle landed on the Sea of Tranquillity, 4 miles (6.4km) downrange from the predicted touchdown point and almost one-and-a-half minutes earlier than scheduled. It was a tense landing: *Eagle* suffered a computer overload and the size of the boulders at the original planned landing site prompted Armstrong to alter course to avoid possible damage, using up almost all the fuel in the process.

Armstrong described to the CAPCOM and Collins what he saw from his window: *"The area out the left-hand window is a relatively level plain cratered with a fairly large number of craters of the five-to-fifty-foot variety, and some ridges that are small, twenty, thirty-feet-high, I would guess, and literally thousands of little, one-and two-foot craters around the area."*

< *The Saturn V launch vehicle for the Apollo 11 mission lifting off at 9:32 a.m. on 16 July 1969.*

Collins commented that it sounded a lot better than the original landing site and Armstrong agreed: *"It really was rough, Mike. Over the targeted landing area, it was extremely rough, cratered, and large number of rocks that were probably – some, many – larger than five or ten feet in size."* When Collins said that when in doubt land long, Armstrong replied: *"That's what we did."*

V *View of the Sea of Tranquillity, the intended landing site, photographed from the Command/Service Module* Columbia.

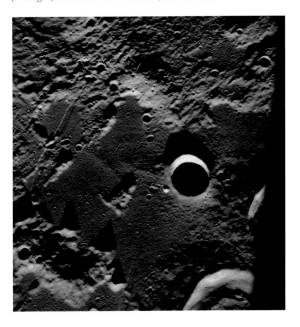

SMALL STEPS & ICONIC IMAGES

The first humans on the Moon's surface stayed for just two-and-a-half-hours, a time filled with photography and experiments. In his biography, *Magnificent Desolation* (the words he used to sum up his first impression of standing on the Moon), Buzz Aldrin gave an insight into NASA's thinking behind the photography:

"Ironically, the photography on the Moon was one of those things that we had not laid out exactly prior to our launch. NASA's public affairs people did not say, 'Hey, you've got to take a lot of pictures of this or that.' Everyone was interested in the science. So, we did the science and the rest of it was sort of gee-whiz. We had not really planned a lot of gee-whiz stuff that, in retrospect, proved quite important. But those pictures became the storyboard of our adventure that the public got to see and are now in the history books."

As Neil Armstrong descended the ladder from the Lunar Module, he released a lever that dropped the side of the equipment bay. Designed to form a flat work surface, it also revealed a television camera that immediately started to transmit slightly indistinct black-and-white images of Armstrong's first step and now-famous words: *"That's one small step for man, one giant leap for mankind."* Aldrin then lowered the Hasselblad via a line to Armstrong, who attached the camera to the fixing on the front of his suit and started working through his shoot list.

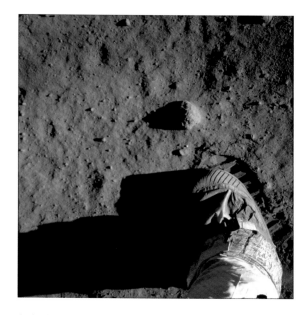

∧ *On Aldrin's shoot list was a 'photo footprint', which was part of an experiment to study the nature of lunar dust and the effects of pressure on the surface. Three weeks after returning from the Moon, on 13 August 1969, the three astronauts were awarded the Medal of Freedom. In his acceptance speech, Aldrin referenced the iconic shot: "What Apollo has begun we hope will spread out in many directions, not just in space, but underneath the seas, and in the cities to tell us unforgettably what we will and must do. There are footprints on the Moon. Those footprints belong to each and every one of you, to all mankind. They are there because of the blood, sweat, and tears of millions of people. Those footprints are the symbol of true human spirit."*

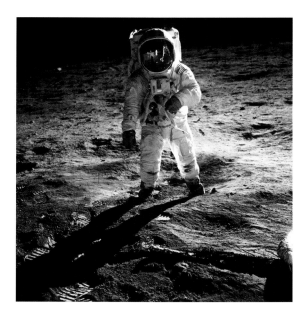

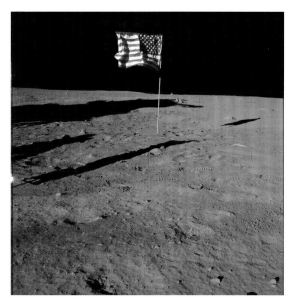

∧ One of the most iconic images taken by Armstrong was never planned and was not even on the shoot list, but it shows his skill as a photographer. It was a picture of Aldrin, who explained: "The most striking photo he took has come to be known as the 'visor shot'. It is probably the one photo from our adventure seen more than any other. Indeed, it may be the most familiar photo from any lunar landing, and perhaps one of the most famous photos in history. It is a simple picture of me standing on the rough lunar surface with my left hand at my waist, with the curve of the horizon easing in to the blackness of space behind me. But if you look more carefully at the reflection in the gold visor on my helmet you can see the Eagle with its landing pad, my shadow and the sun's halo effect, several of the experiments we had set up, and even Neil taking the picture. It is a truly astounding shot."

∧ Another memorable shot was that of the American flag, which had a rod along its top edge to support it and create the illusion of it 'flying', despite the Moon's lack of atmosphere. Buzz Aldrin later reported that on departure from the lunar surface, he witnessed the flag fall over, hit by the exhaust of the Lunar Module. In 2012, photographs of the Moon's surface revealed shadows cast by all the Apollo flags, with the exception of Apollo 11, confirming Aldrin's story.

HASSELBLAD & SCIENTIFIC OBSERVATION

The Hasselblad camera played a major role in scientific observation on the Moon, with the imagery providing a clear vision of another world while also helping to explain the activities of the astronauts. These were listed on 'cuff checklists' sewn on to each astronaut's glove and included:

• The Lunar Laser Ranging Experiment: designed to accurately calculate the distance between Earth and the Moon by using reflectors to bounce a laser beam back to its source. As well as providing a very precise distance measurement of the Moon from Earth (238,897 miles/384,467km) it provided great insights into the Moon's orbit and rotation, and revealed that the Moon is moving away from Earth at a rate of 1½in (3.8cm) every year.

• The Passive Seismic Experiment: designed to measure 'Moonquakes' and impacts from meteoroids or man-made objects as well as the Moon's internal structure.

V *Neil Armstrong's cuff checklist.*

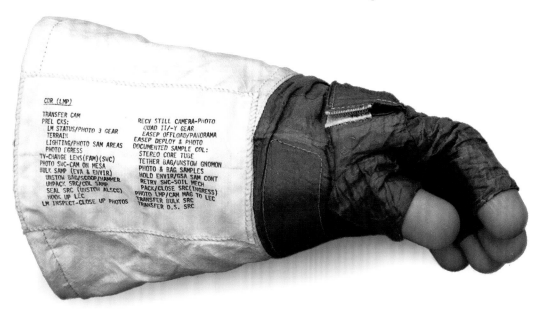

- The Solar Wind Compositional Experiment: which used an aluminium panel to collect atomic particles released into space by the Sun. During 77 minutes, it captured ions of helium, neon and argon.

- The Soil Mechanics Investigation: which studied the mechanical properties of the Moon's soil.

- Lunar Field Geology: involving the collection of geologic rock samples that were documented, packed and stowed. Apollo 11 brought back nearly 48lb (22kg) of rock and soil samples.

- Handheld Hasselblad Photography: which recorded the lunar surface activities. The deployment of the experiments and the nature of the landscape were shot with the Hasselblad, providing a photographic record of the first exploration of the Moon and a narrative to be enjoyed by armchair astronauts the world over.

V *Aldrin erecting the Solar Wind Compositional Experiment.*

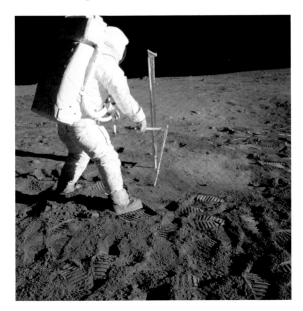

V *Aldrin deploying the Passive Seismic Experiment.*

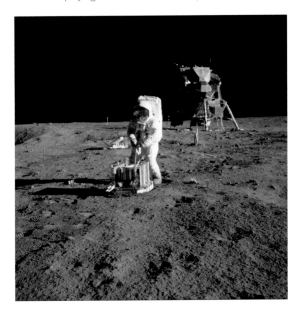

PANORAMAS

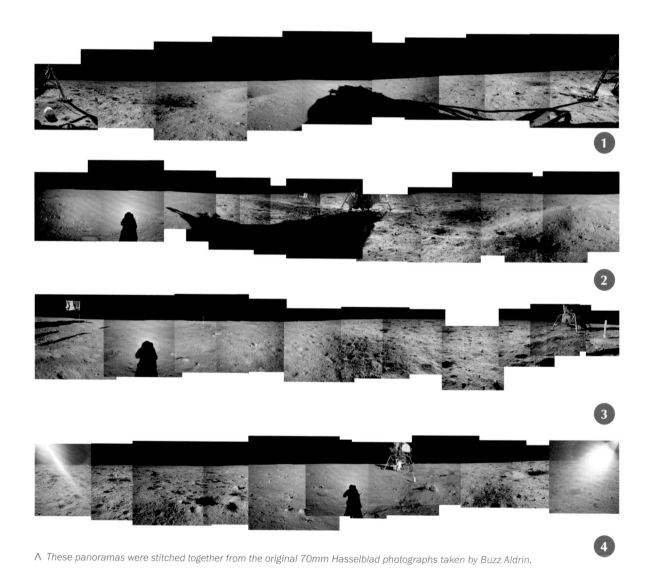

Λ These panoramas were stitched together from the original 70mm Hasselblad photographs taken by Buzz Aldrin.

HASSELBLAD & THE MOON LANDING

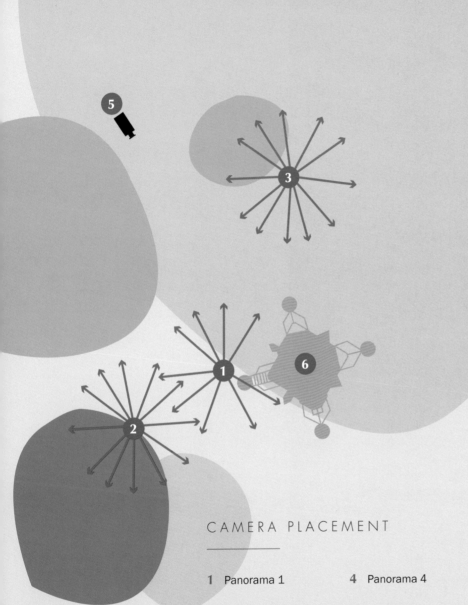

CAMERA PLACEMENT

1	Panorama 1	**4**	Panorama 4
2	Panorama 2	**5**	TV Camera
3	Panorama 3	**6**	Lunar Module

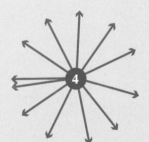

LEAVING THE CAMERAS BEHIND

Today, there are two Hasselblad cameras on the Sea of Tranquillity and a total of 12 Hasselblads on the Moon's surface. To reduce weight on the return journey, any non-essential items were jettisoned, and, after stowing the film backs containing the exposed film, the camera body and lens of the silver Hasselblad 500EL Data Camera and the Hasselblad 500EL from the Lunar Module were left behind.

Lift-off from the Moon went smoothly, the Lunar Module separated from its base and ascended to rendezvous with the Command/Service Module. After transferring all the film and rock boxes, Collins released the Lunar Module, which floated away into space. The next critical action was the two-and-a-half-minute burn to take them out of lunar orbit, which took place on the far side of the Moon, out of contact with Earth.

Collins recalled that they all took turns with the camera, taking images of the Moon and Earth: *"The Moon from this side is full, a golden brown globe glorying in sunshine. It is an optimistic cheery view, but all the same, it is wonderful to look out the window and see it shrinking and the tiny Earth growing."*

Perhaps the most uncomfortable part of the mission was the splashdown. The Module landed in rough seas and tipped up, leaving the astronauts hanging from their straps looking into the water. Eventually, they were picked up by a helicopter and taken to the waiting USS Hornet, which had a mobile quarantine facility in which the Apollo crew would spend five days.

Over 530 million people watched the Moon landing on television, and there was intense interest. The film magazines were developed quickly and the sensational photographs reproduced around the world, with magazines such as *Life* printing special editions. Victor Hasselblad was invited to see the launch of Apollo 11 and was given a duplicate set of images that he took back to Sweden: the success of the Hasselblad on the Moon was one of his greatest achievements.

> *Apollo 11 crew in quarantine as President Richard M. Nixon welcomes the astronauts aboard the USS* Hornet.

V *Apollo 11 crew await pickup by helicopter following splashdown. The fourth man in the raft is a USA Navy underwater demolition team swimmer.*

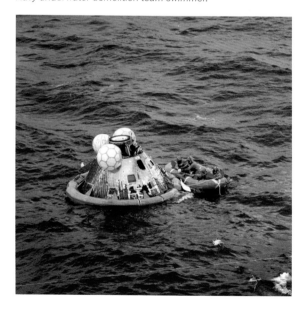

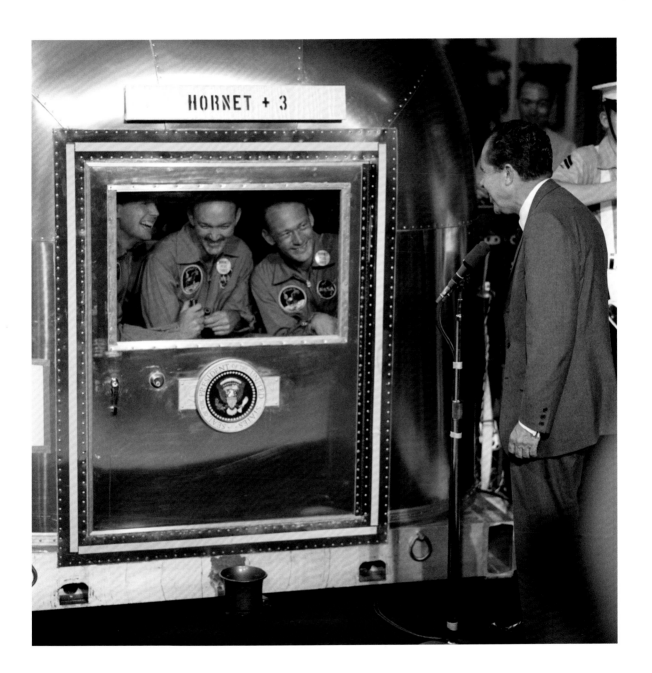

CONSPIRACY THEORIES

In the decade that followed the Apollo 11 mission, conspiracy theories about the Moon landing started to appear. Underlying these was the notion that it had all been faked, and that humans had not actually set foot on the Moon. The images taken by the Hasselblad were ironically cited as evidence of this grand deception.

Bill Kaysing was the author of the first book on the subject, *We Never Went To The Moon: America's Thirty Billion Dollar Swindle*, which he self-published in 1976. Kaysing used many of the Apollo 11 photographs in his main arguments, claiming that they prove the Moon landing to have been faked. Here are some of the arguments raised by Kaysing and other conspiracy theorists, and some of the explanations that represent the counter-arguments:

CONSPIRACY: There is an absence of stars in the lunar surface photographs.
COUNTER-ARGUMENT: During the Moon's 'daytime' (when Aldrin and Armstrong were on the Moon's surface), there is intense light from the Sun, which dominates the sky and drowns out the faint light from the stars. There is also reflected light from the Moon's surface, which adds to the brightness.

CONSPIRACY: There are no blast craters beneath the Lunar Module.
COUNTER-ARGUMENT: Gravity on the Moon is one-sixth that of Earth, which has a profound effect on forces. The Lunar Module's blast radiated out, rather than being centred in one spot, making the blast far less intense.

CONSPIRACY: The landing was staged in Building 9 at the Johnson Space Center in Houston. It was not helped that Stanley Kubrick's ground-breaking science fiction film, *2001: A Space Odyssey,* was released the year before.
COUNTER-ARGUMENT: The rehearsals of the EVAs, in Building 9, covered all aspects of the lunar surface work. Perhaps one of the most compelling arguments is that these EVA exercises were not kept secret: for a hoax, there would surely have been greater security around them.

∨ *The image of the flag has been used by conspiracy theorists because the flag appeared to flutter in the wind. When the flag was unfolded it retained its crumpled appearance and always appeared with the same creases in all the photographs.*

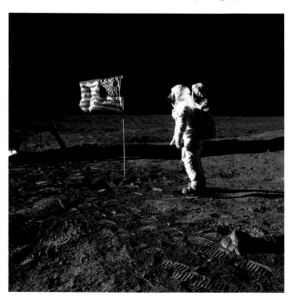

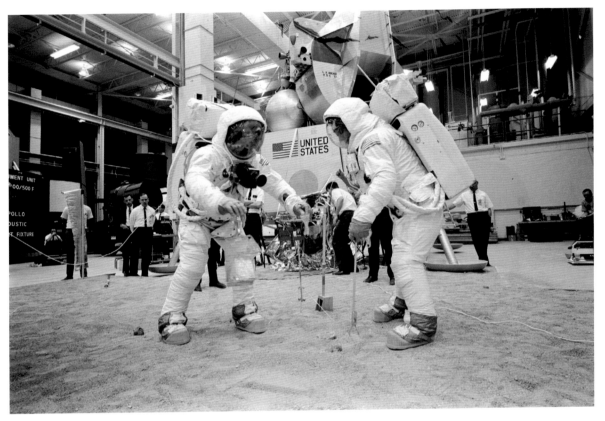

∧ *Kaysing reproduced pictures taken during the practise sessions showing Aldrin and Armstrong in full spacesuits, and suggested that finishing the sets in the rehearsal studio would have created a realistic impression of the Moon.*

CONSPIRACY: The angle and colour of shadows is inconsistent, suggesting that artificial lighting was used.

COUNTER-ARGUMENT: There is a lot of reflected light from the Moon's surface, as well as undulating terrain, which complicates shadow positions and 'fills in' dark areas just like a standard photographic reflector. Craters and dips can also cause shadows to appear longer, shorter or even distorted.

CONSPIRACY: The quality of the photographs is implausibly high.

COUNTER-ARGUMENT: This is partly because of the quality of the Hasselblad camera, lens and medium-format film, and partly because only the best images were selected for release. Plenty were blurred or not framed particularly well, but NASA did not release them.

THE MISSION

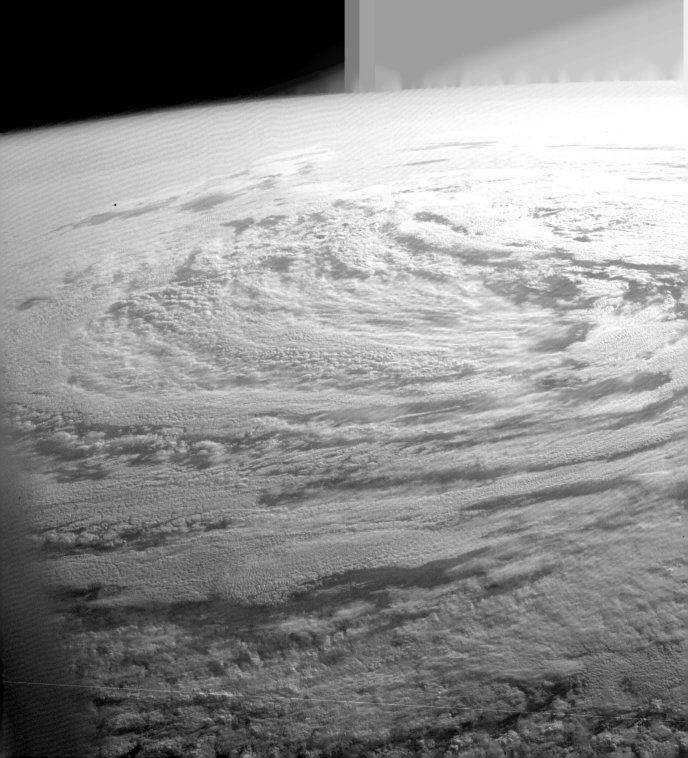

00: 01: 19: 57 COLLINS:
JESUS CHRIST, LOOK AT THAT HORIZON.

00: 01: 19: 59 ARMSTRONG:
ISN'T THAT SOMETHING?

00: 01: 20: 00 COLLINS:
GOD, THAT'S PRETTY; IT'S UNREAL.

00: 01: 20: 08 ARMSTRONG:
GET A PICTURE OF THAT.

00: 01: 20: 10 COLLINS:
OOH, SURE, I WILL. I'VE LOST A HASSELBLAD... HAS ANYBODY SEEN A HASSELBLAD FLOATING BY? IT COULDN'T HAVE GONE VERY FAR – BIG SON OF A GUN LIKE THAT.

< **Sunrise**
The view from Earth's orbit. Michael Collins photographed Earth, looking east towards the Sun. By this point, the rising Sun had revealed the formation of a low-pressure cell.

Key: Mission Clock
DAYS: HOURS: MINUTES: SECONDS

00: 03: 21: 19 COLLINS:
YES, IT'S SIX FRAMES AT 15;
I SUGGEST TOWARD THE END YOU
PROBABLY GOOSE IT UP A LITTLE BIT.

00: 03: 21: 23 ALDRIN:
YOU WANT TO GET THE WHOLE THING?

00: 03: 21: 24 ARMSTRONG:
I DON'T CARE...TELL BY LOOKING AT...

00: 03: 21: 32 ALDRIN:
THE THING IS, WITH THIS SITTING THERE,
I CAN'T GET MUCH WITH THE HASSELBLAD.
THAT WINDOW'S NO GOOD, I'M AFRAID.

Transposition and docking >

*Having left Earth's orbit, Buzz Aldrin took a series of seven
shots with the Hasselblad as the Command/Service Module
positioned itself and prepared to dock with the Lunar Module.*

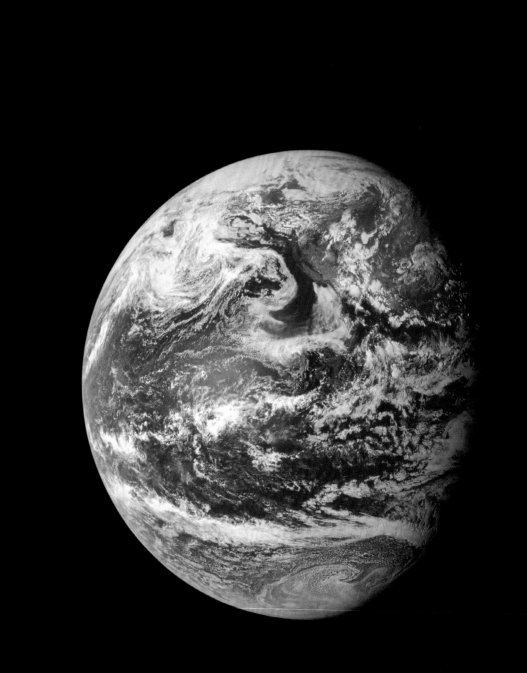

WELL, OF COURSE, THE EARTH IS PRETTY BRIGHT, AND THE BLACK SKY, INSTEAD OF BEING BLACK, HAS SORT OF A ROSY GLOW TO IT. THE STAR, UNLESS IT IS A VERY BRIGHT ONE, IS PROBABLY LOST SOMEWHERE IN THAT GLOW, BUT IT IS JUST NOT VISIBLE. I MANEUVERED THE RETICLE CONSIDERABLY ABOVE THE HORIZON TO MAKE SURE THAT THE STAR IS NOT LOST IN THE BRIGHTNESS BELOW THE HORIZON. HOWEVER, EVEN WHEN I GET THE RETICLE CONSIDERABLY ABOVE THE HORIZON SO THE STAR SHOULD BE SEEN AGAINST THE BLACK BACKGROUND, IT STILL IS NOT VISIBLE.

< **Earth view**
This view of Earth was photographed from roughly 10,000 nautical miles away. The photograph shows the Pacific Ocean as well as the continents of North and Central America.

03: 04: 05: 32 ALDRIN:
OH, GOLLY, LET ME HAVE THAT CAMERA BACK.
THERE'S A HUGE, MAGNIFICENT CRATER OVER HERE.
I WISH WE HAD THE OTHER LENS ON,
BUT GOD, THAT'S A BIG BEAUTY.
YOU WANT TO LOOK AT THAT GUY, NEIL?

03: 04: 05: 43 ARMSTRONG:
YES, I SEE HIM.

03: 04: 05: 45 ALDRIN:
HE'S COMING YOUR WAY.

Craters of the Moon >
This photograph was taken on approach to the landing
site and shows Crater Daedalus. Daedalus is an impact
crater on the far side of the Moon and has a diameter of
57 miles (93km) and a total depth of 1.9 miles (3km).

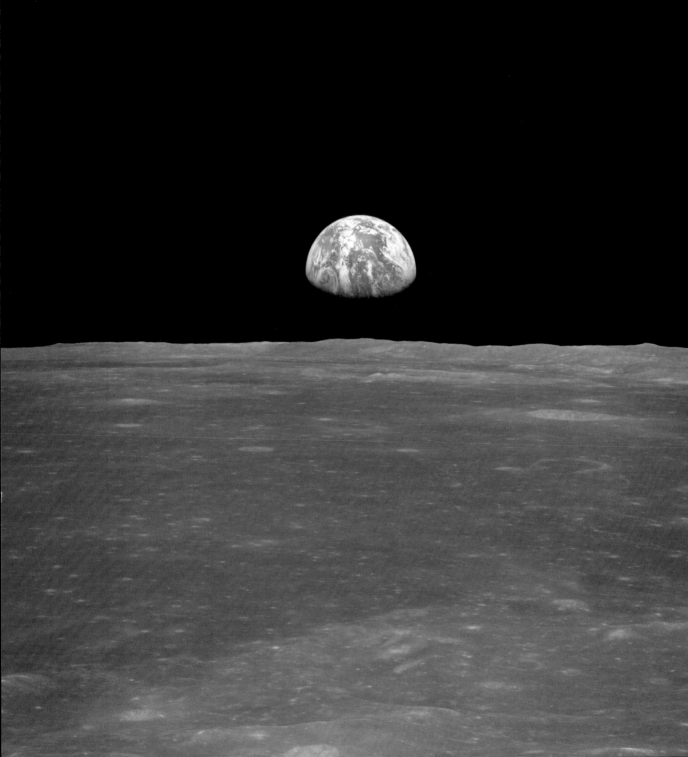

03: 04: 14: 57 COLLINS:
OKAY, WE SHOULDN'T TAKE ANY MORE PICTURES ON THIS
ROLL UNTIL EARTH COMES, I DON'T THINK; THIS IS...

03: 04: 15: 01 ARMSTRONG:
ABOUT OUT?

03: 04: 15: 02 COLLINS:
JUST ABOUT OUT AND IT'S ON OUR LAST COLOR ROLL,
SO WE'LL SWITCH TO BLACK AND WHITE
AS SOON AS WE GET TO EARTH.

03: 04: 15: 13 ALDRIN:
THERE IT IS, IT'S COMING UP.

< **Earthrise**
*Earth rising above the horizon of the Moon. The lunar
terrain below is known as Mare Smythii, which is Latin
for 'Sea of Smyth', and is named after the 19th-century
British astronomer, William Henry Smyth.*

04: 04: 17: 15 ARMSTRONG:
THE MESA'S STILL UP?

04: 04: 17: 19 COLLINS:
YES.

04: 04: 17: 20 ARMSTRONG:
GOOD.

04: 04: 17: 49 COLLINS:
NOW, YOU'RE LOOKING GOOD.

04: 04: 17: 59 ALDRIN:
ROGER. EAGLE'S UNDOCKED. THE EAGLE HAS WINGS. LOOKING GOOD.

Journey to the Moon >
*After the Command/Service Module and Lunar
Module separated, Michael Collins began a visual
inspection of the landing gear of the Lunar Module.*

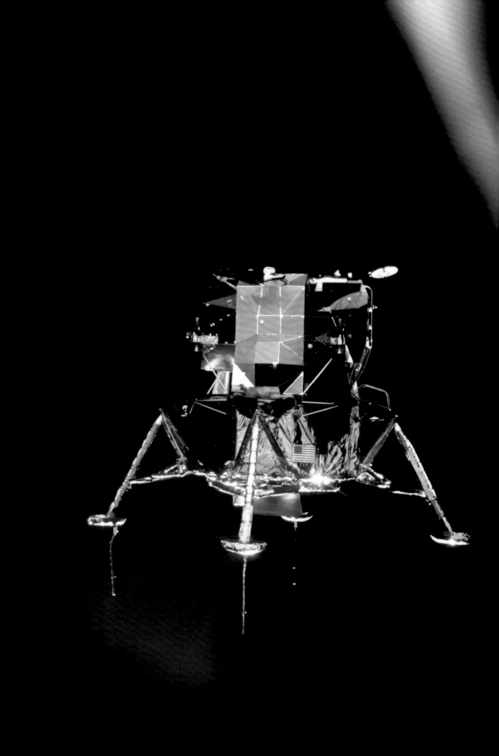

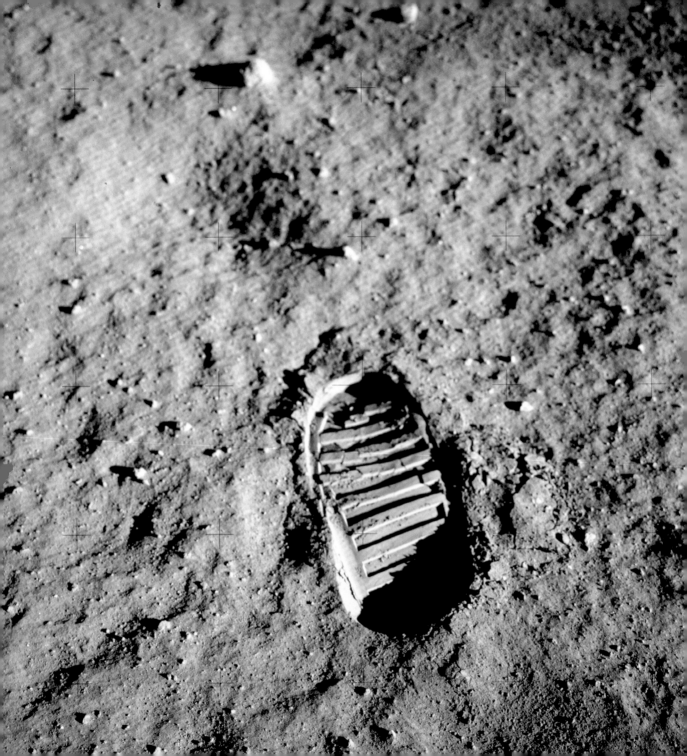

04: 13: 23: 38 ARMSTRONG:

I'M AT THE FOOT OF THE LADDER. THE LM FOOTPADS ARE ONLY DEPRESSED IN THE SURFACE ABOUT 1 OR 2 INCHES, ALTHOUGH THE SURFACE APPEARS TO BE VERY, VERY FINE GRAINED, AS YOU GET CLOSE TO IT. IT'S ALMOST LIKE A POWDER. DOWN THERE, IT'S VERY FINE.

04: 13: 23: 43 ARMSTRONG:

I'M GOING TO STEP OFF THE LM NOW.

04: 13: 24: 48 ARMSTRONG:

THAT'S ONE SMALL STEP FOR MAN, ONE GIANT LEAP FOR MANKIND.

< **The footprint**
The iconic photo of Buzz Aldrin's footprint was in fact a soil mechanics test, used to show the depth of his footprint, but its importance was more than that, as Aldrin explained: "Framed in the photo was evidence of man on the Moon."

04: 13: 42: 28 ARMSTRONG:
YOU'VE GOT THREE MORE STEPS AND THEN A LONG ONE.

04: 13: 42: 42 ALDRIN:
OKAY. I'M GOING TO LEAVE THAT ONE FOOT UP THERE AND BOTH HANDS DOWN TO ABOUT THE FOURTH RUNG UP.

04: 13: 42: 50 ARMSTRONG:
THERE YOU GO.

04: 13: 42: 53 ALDRIN:
OKAY. NOW I THINK I'LL DO THE SAME.

04: 13: 43: 01 ARMSTRONG:
A LITTLE MORE. ABOUT ANOTHER INCH.

04: 13: 43: 05 ARMSTRONG:
THERE YOU GOT IT.

Leaving the Lunar Module >
*Neil Armstrong photographed Buzz Aldrin's descent from
the Lunar Module. However, leaving the Lunar Module in full
spacesuit and helmet was a tricky operation, as there was as
little as 1in (2.5cm) of clearance in some places.*

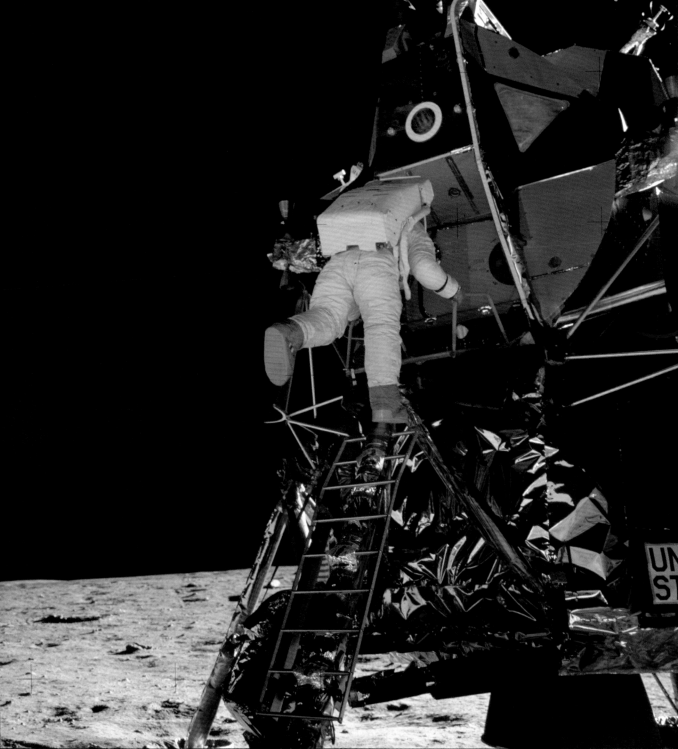

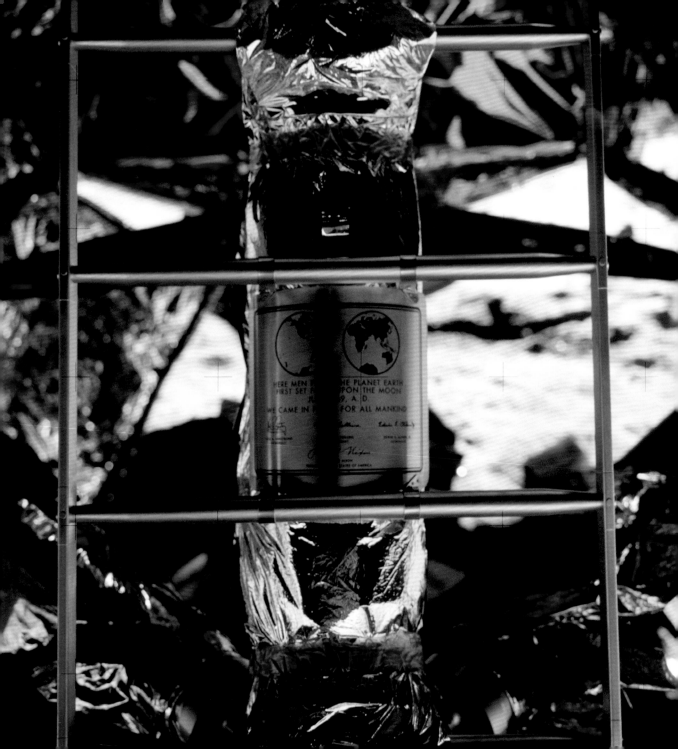

04: 13: 51: 35 MCCANDLESS:
NEIL, THIS IS HOUSTON.
THAT'S AFFIRMATIVE.
WE'RE GETTING A NEW PICTURE.
YOU CAN TELL IT'S A LONGER FOCAL LENGTH LENS.
AND FOR YOUR INFORMATION,
ALL LM SYSTEMS ARE GO.
OVER.

04: 13: 51: 46 ALDRIN:
WE APPRECIATE THAT. THANK YOU.

04: 13: 52: 19 ALDRIN:
NEIL IS NOW UNVEILING THE PLAQUE.

< **"We came in peace"**
Neil Armstrong described the problems he had
photographing the plaque that would be left behind
on the Moon as a permanent record of the landing:
"We had to guess at the exposure, so I took several
different exposures to try to catch the plaque."

04: 14: 03: 20 ARMSTRONG:

OKAY. YOU CAN MAKE A MARK, HOUSTON.

04: 14: 03: 24 MCCANDLESS:

ROGER. SOLAR WIND.

04: 14: 03: 36 ALDRIN:

AND, INCIDENTLY, YOU CAN USE THE SHADOW THAT THE STAFF MAKES TO GET IT PERPENDICULAR

04: 14: 03: 50 MCCANDLESS:

ROGER.

Solar Wind Compositional Experiment >
Buzz Aldrin stands to the side of the Solar Wind Compositional Experiment he has just set up, pointing towards the sun. It was left in place for 1 hour and 17 minutes, then rolled up, bagged and stowed ready for analysis back on Earth.

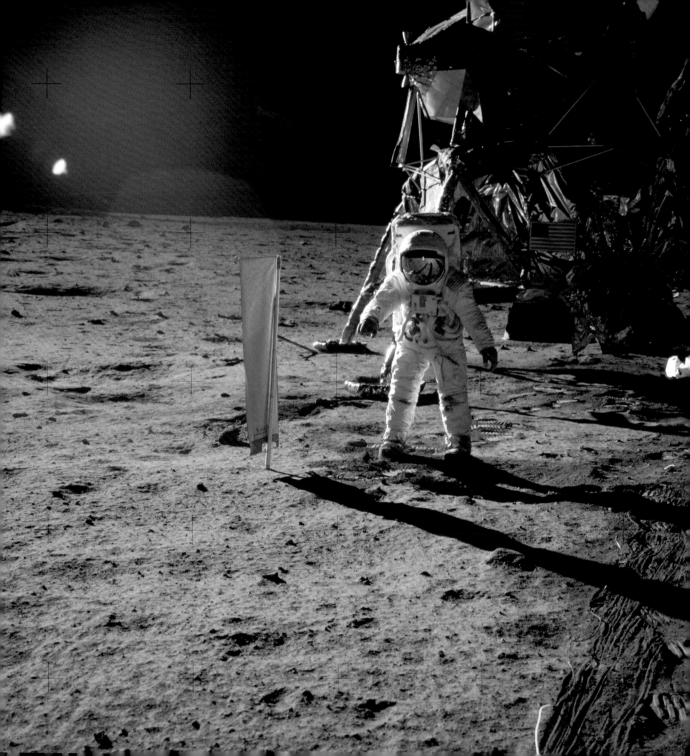

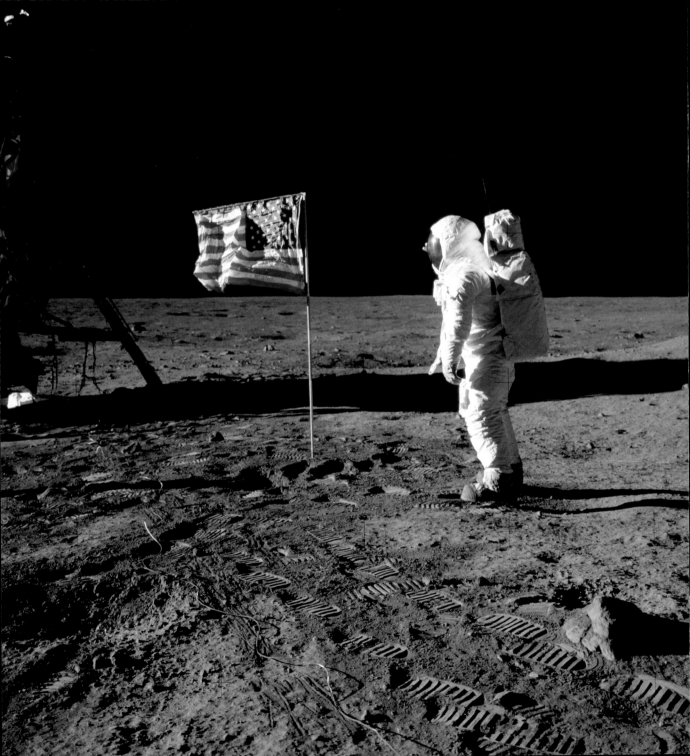

04: 14: 09: 18 MCCANDLESS:
I GUESS YOU'RE ABOUT THE ONLY PERSON AROUND THAT
DOESN'T HAVE TV COVERAGE OF THE SCENE.

04: 14: 09: 25 COLLINS:
THAT'S ALRIGHT. I DON'T MIND A BIT.

04: 14: 09: 33 COLLINS:
HOW IS THE QUALITY OF THE TV?

04: 14: 09: 35 MCCANDLESS:
OH, IT'S BEAUTIFUL, MIKE. IT REALLY IS.

04: 14: 09: 39 COLLINS:
OH, GEE, THAT'S GREAT! IS THE LIGHTING
HALF WAY DECENT?

04: 14: 09: 43 MCCANDLESS:
YES, INDEED. THEY'VE GOT THE FLAG UP NOW AND YOU
CAN SEE THE STARS AND STRIPES ON THE LUNAR SURFACE.

< **Saluting the flag**
In the post-mission press conference Neil Armstrong explained that "We had some difficulty, at first, getting the pole of the flag to remain in the surface. In penetrating the surface, we found that most objects would go down about five, maybe six inches."

04: 14: 31: 29 ALDRIN:
THE PANORAMA I'LL BE TAKING IS ABOUT 30 OR 40 FEET
OUT TO PLUS...

04: 14: 31: 39 MCCANDLESS:
SAY AGAIN WHICH STRUT, BUZZ?

04: 14: 31: 43 ALDRIN:
THE PLUS Z STRUT.

Panorama 2 >
*This image from Buzz Aldrin's plus-Z pan is the only direct
photograph of Neil Armstrong on the surface of the Moon.
For the majority of the time on the lunar surface, Armstrong
held the camera, while Aldrin conducted experiments.*

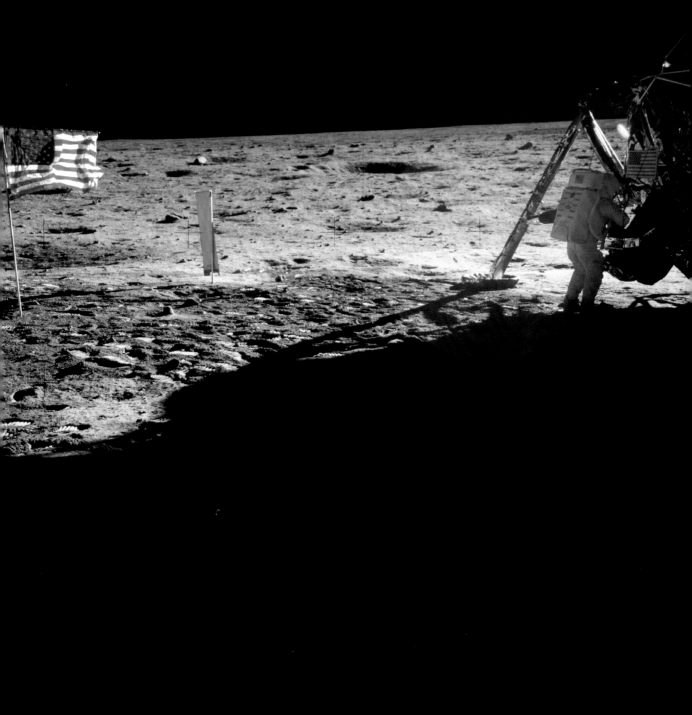

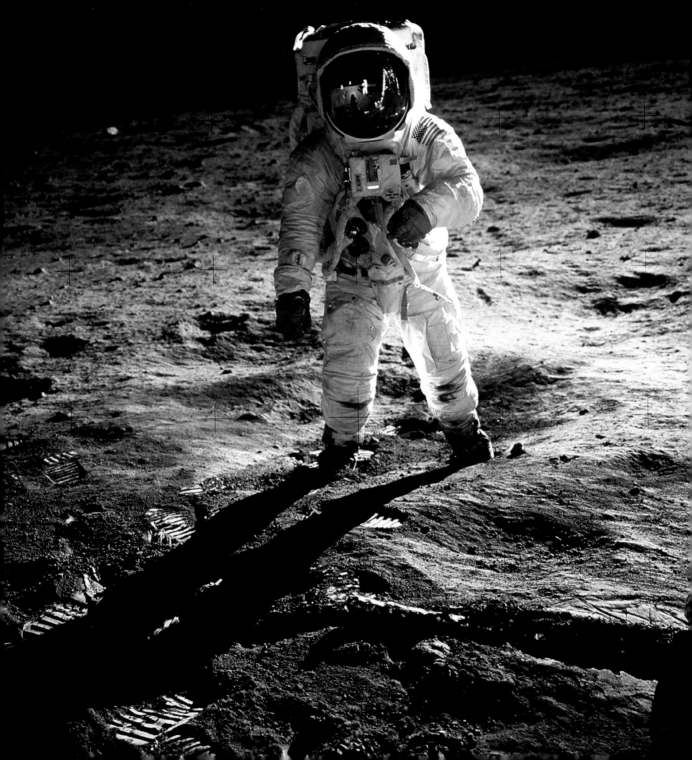

04: 14: 41: 25 ALDRIN:
AND, HOUSTON? BUZZ HERE.
I'M SHOWING 3.78 PSI, 63 PERCENT,
NO FLAGS, ADEQUATE, SLIGHT WARMING.

04: 14: 42: 01 ARMSTRONG:
ROGER. AND NEIL HAS 66 PERCENT O_2,
NO FLAGS, MINIMUM COOLING,
AND THE SUIT PRESSURE IS 382.

04: 14: 42: 14 MCCANDLESS:
HOUSTON. ROGER. OUT.

< **The visor shot**
Just after a communication with McCandless, Neil Armstrong took the photograph known as the 'visor shot', which is the most reproduced photograph of all those taken on the Moon's surface. In this full-length photograph, the reflection in the visor shows Tranquillity base and the photographer, Armstrong.

04: 14: 50: 26 ALDRIN:
JUST TOO BIG AN ANGLE, NEIL.

04: 14: 50: 34 ARMSTRONG:
YEAH. I THINK YOU ARE RIGHT.

View of Earth over the Lunar Module >
*Looking up and leaning back to capture this view of Earth
above the Lunar Module was difficult because of the stiffness
of the spacesuits and the rigid Portable Life Support System.
Australia is just visible in sunlight on Earth.*

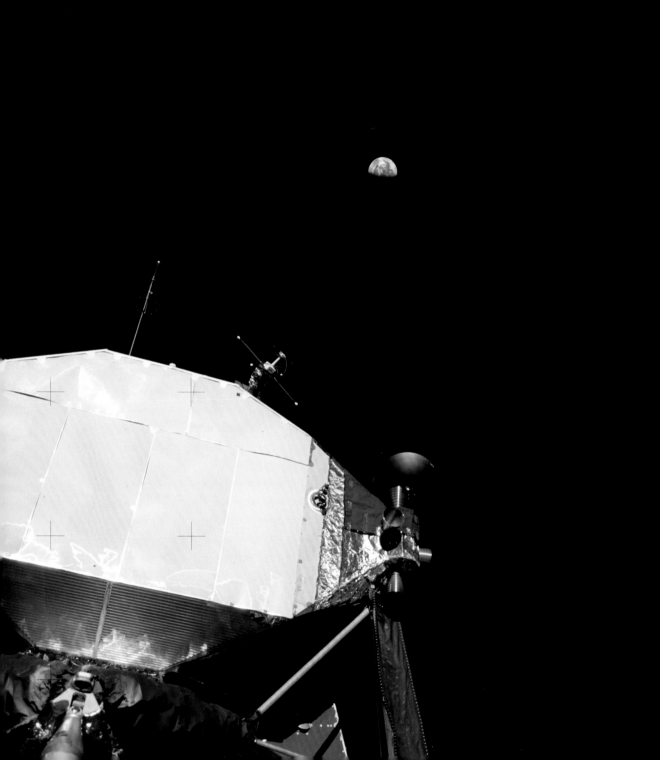

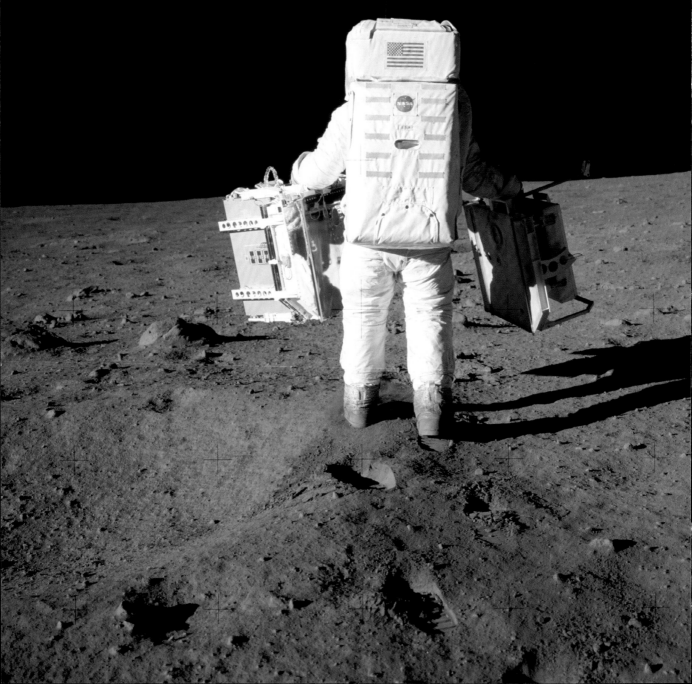

04: 15: 02: 49 ALDRIN:

ROGER. I SAY I'M NOT HAVING TOO MUCH SUCCESS IN
LEVELING THE PSE EXPERIMENT.

04: 15: 03: 57 ARMSTRONG:

THE LASER REFLECTOR IS INSTALLED AND THE BUBBLE IS
LEVELED AND THE ALIGNMENT APPEARS TO BE GOOD.

04: 15: 04: 16 MCCANDLESS:

NEIL, THIS IS HOUSTON. ROGER. OUT.

< **Buzz Aldrin carrying experiment packages**
*Buzz Aldrin carrying the Lunar Laser Ranging and
seismometer package. Aldrin had difficulty in finding a level
surface to set up the experiments: "As I would bend down
and look at this thing, it just appeared that this cup – instead
of being concave – had somehow changed its shape and
was convex."*

05 : 04 : 32 : 55 ARMSTRONG:

ROGER, HOUSTON.
THE EAGLE IS BACK IN ORBIT, HAVING LEFT TRANQUILLITY
BASE AND LEAVING BEHIND A REPLICA FROM OUR APOLLO
11 PATCH AND THE OLIVE BRANCH.

05 : 04 : 33 : 15 EVANS:

EAGLE, HOUSTON. ROGER. WE COPY.
THE WHOLE WORLD IS PROUD OF YOU.

05 : 04 : 33 : 26 ARMSTRONG:

WE HAD A LOT OF HELP DOWN THERE.

Heading home >
*After a successful mission, Armstrong is photographed in the
Lunar Module heading back to the Command/Service Module.
While moving inside the cabin, Aldrin accidentally damaged
the circuit breaker that would arm the main engine for lift off
from the Moon. Fortunately, a felt-tip pen was sufficient to
activate the switch.*

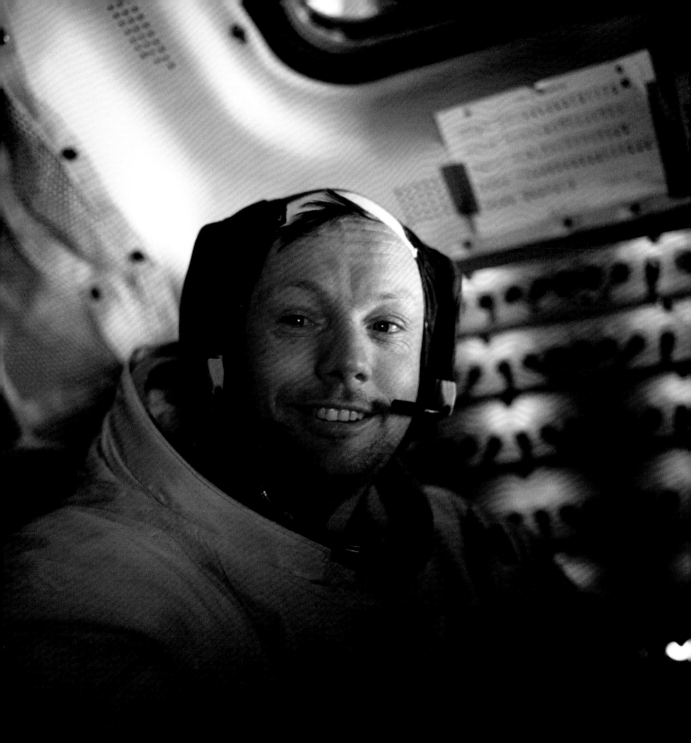

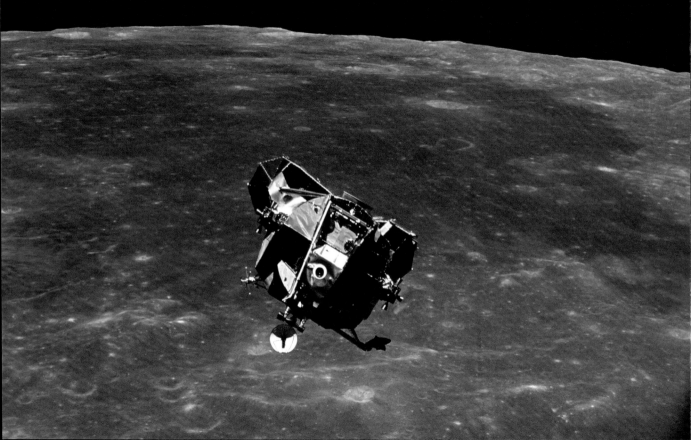

05: 07: 51: 29 ARMSTRONG:
I'LL BE LOOKING INTO HIS LEFT WINDOW
WHEN I PITCH UP.

05: 07: 51: 32 ALDRIN:
I DON'T THINK SO.
IF YOU DID IT RIGHT NOW YOU'D...

05: 07: 51: 36 COLLINS:
...I GOT THE EARTH COMING UP ALREADY; IT'S FANTASTIC!

< **Earth, the Moon and the Lunar Module**
*Taken just before the Lunar Module and Command/Service
Module docked, Michael Collins managed to take this
photograph of Earth, the Moon and the Lunar Module.*

05: 15: 31: 34 ARMSTRONG:
WHAT ARE YOU DOING, MIKE?
WHAT YOU TAKING PICTURES OF?

05: 15: 31: 40 COLLINS:
OH, I DON'T KNOW.
WASTING FILM, I GUESS.

The Moon at 10,000 nautical miles >
*This full view of the Moon was taken when Columbia was
on its journey homeward. It was taken with an 80mm lens
using the Hasselblad 500EL that had stayed on board
Columbia with Michael Collins.*

GLOSSARY

CAPCOM: The CAPsule COMmunicator, providing a communication link between Flight Control and astronauts.

collodion process: A photographic process, using collodion (cellulose nitrate) to produce a negative.

Columbia: The call sign for the Apollo 11 Command/Service Module.

Command/Service Module: The Apollo spacecraft, which consisted of two sections: the Command Module housing the astronauts and their equipment, and the Service Module providing propulsion and power. The Command Module was the only part of the mission to return to Earth.

daguerreotype: The first commercially successful photographic process. The method produces direct positive images on a silver-coated copper plate.

Eagle: The call sign for the Apollo 11 Lunar Module. It was named after the national bird of the USA, the bald eagle.

Earth's limb: The visual edge of Earth at the horizon.

EMU: Extravehicular Mobility Unit, the spacesuit worn by astronauts performing Extravehicular Activity (EVA).

EVA: Extravehicular Activity, any task conducted outside of the spacecraft. Most commonly applies to a spacewalk, and on Apollo 11 refers to the exploration of the Moon's surface.

geocentric orbit: refers to any object orbiting Earth, including the Moon and made-made satellites.

Lunar Module: A lander designed for space operations on the Moon and to transport astronauts to and from the Command/Service Module.

NASA: The National Aeronautics and Space Administration.

Réseau plate: A glass plate with small hairline crosses engraved on its surface, used to determine the distance between objects within an image.

Sea of Tranquillity: A large plain located in the northern hemisphere of the Moon.

PICTURE CREDITS

BIBLIOGRAPHY

Books

Aldrin, Buzz & Abraham, Ken. *Magnificent Desolation.* (Bloomsbury, 2009)

Baldwin, Gordon. *Looking at Photographs.* (Getty BMP, 1991)

Baldwin, Gordon, Daniel, Malcolm & Greenough, Sarah. *All the Mighty World.* (Yale University Press, 2004)

Carpenter, M. Scott, Cooper, Gordon Jr., Glenn, John H. Jr., Grissom, Virgil, Schirra, Walter (Wally) Jr., Shepard, Alan Jr. & Slayton, Donald K. *We Seven.* (Simon & Schuster, 1962)

Burgess, Colin & Hall, Rex. *The First Soviet Cosmonaut Team.* (Praxis Publishing, 2009)

Collins, Michael. *Carrying The Fire: An Astronaut's Journey.* (Cooper Square Press, 2001)

Emanuel, W. D. *Hasselblad Guide.* (Focal Press, 1962)

Glenn, John & Taylor, Nick. *John Glenn: A Memoir.* (Bantam Books, 1999)

Hansen, James R. *First Man, The Life of Neil Armstrong.* (Simon & Schuster, 2005)

Hershkowitz, Robert. *The British Photographer Abroad.* (Parkside Press, 1980)

Karlsten, Evald. *Hasselblad.* (Gullivers International AB, 1981)

Kaysing, Bill. *We Never Went to the Moon: America's Thirty Billion Dollar Swindle.* (Self-published, 1976)

French, John, Mendes, Valerie, Szygenda, Lynn & French, Vere. *John French: Fashion Photographer.* (Victoria and Albert Museum, 1984)

Nasmyth, James & Carpenter, James. *The Moon: Considered as a Planet, a World, and a Satellite.* (Bradbury, Agnew & Co., 1874)

Price, William Frederick Lake. *Manual of Photographic Manipulation.* (John Churchill & Sons, 1868)

Schirra, Wally & Billings, Richard. *Schirra's Space.* (Blue Jacket Books, 1988)

Smiles, Samuel. *James Nasmyth, Engineer: An Autobiography.* (Exho Library, 2006)

Verne, Jules. *From the Earth to the Moon.* (Scribner, Armstrong & Company, 1874)

Online

www.hq.nasa.gov/alsj/apollo.photechnqs.htm

www.hq.nasa.gov/alsj/a11/a11-hass.html

www.hq.nasa.gov/alsj/a11/a11.html

www.airandspace.si.edu/multimedia-gallery/5239hjpg?id=5239

www.hq.nasa.gov/alsj/a11/images11.html#Mag40

www.apolloarchive.com/apollo_gallery.html

www.history.nasa.gov/ap11ann/kippsphotos/apollo.html

www.hasselblad.com

www.cfa.harvard.edu/hco/grref.html

www.history.nasa.gov/sputnik

www.hasselbladfoundation.org/wp/history/the-hasselblad-camera

www.proftimobrien.com/2013/12/how-times-change-change-3-and-luna-9

www.history.nasa.gov/apollo_photo.html

www.hq.nasa.gov/alsj/a11/a11-hass.html

www.hq.nasa.gov/alsj/apollo.photechnqs1.pdf

www.computerweekly.com/feature/Apollo-11-The-computers-that-put-man-on-the-Moon

Films

Mission Control: The Unsung Heroes of Apollo
Directed by David Fairhead (2017, Haviland Digital)

Shadow of the Moon
Directed by David Sington (2007, Film4)

INDEX

A

Adams, Ansel 24

Aldrin, Buzz 9, 34, 35, 36, 37, 40, 42, 43, 44, 45, 47, 51, 53, 71, 75, 80, 84

Anders, Bill 32

Apollo 1 32

Apollo 7 15, 27, 32, 33

Apollo 8 15, 32

Apollo 9 15, 32, 33

Apollo 10 15, 32, 33

Apollo 11 15

 Command/Service Module (*Columbia*) 19, 32, 43

 conspiracy theories 52–53

 'cuff checklists' 46–47

 flag images 45, 52, 76, 79

 footprint images 44, 68

 Lunar Module (*Eagle*) 43, 50, 59, 67, 71, 88

 Mission Control 40, 41

 panoramas 48–49

 photographic equipment 34, 38, 44, 50

 plaque 72

 preparations 34

 return to earth 50, 51

 Saturn V launch vehicle 6, 42, 42

 scientific experiments 46–47, 75, 84

 'visor shot' 45, 80

 see also Aldrin, Buzz; Armstrong, Neil; Collins, Michael

Archer, Frederick Scott 19

Armstrong, Neil 34, 34, 36, 43, 44, 51, 53, 79, 87

B

Bond, William Cranch 18

C

CAPCOM 40

Chaffee, Roger 32

chest fixing 38

Collins, Michael 34, 36, 37, 42, 43, 50, 51

Command/Service Module (*Columbia*) 19, 32, 43

Conger, Dean 27

Cooper, Gordon 27

D

daguerreotypes 18–19

Davies, John Grant 30–31

De la Rue, Warren 18

Duke, Charlie 36, 40

E

Eagle see Lunar Module

Earth, views of 33, 56, 60, 83, 88

'Earthrise' 32, 33, 64

F

French, John 25

G

Gagarin, Yuri 20

Gemini missions 13–14, 28, 29

Glenn, John 27

Goalen, Barbara 25

Grissom, Virgil 'Gus' 32

H

Hasselblad, Victor 22–23, 24, 38, 50

Hasselblad cameras

 500C 24, 26, 27, 28, 32

 500EL 10–11, 22, 25, 32, 34, 38, 39, 50

 500EL Data Camera 8, 38, 39, 50

 1000F 24

 1600F 24

 HK7 22, 23

 SKa4 23

 Super Wide 25

 Super Wide C 25

I

International Council for Scientific
Unions 20

K

Kaysing, Bill 52
Kennedy, John F. 20, 21
Kubrick, Stanley: *2001: A Space
Odyssey* 52

L

lenses
Meyer 22
Schneider 22
Xenotar 14
Zeiss 12, 13, 14, 15, 22, 26,
28, 34, 38
Leonov, Alexei 20
Lovell Telescope 30
Luna programme 30–31
Lunar Module (*Eagle*) 43, 50, 59,
67, 71, 88
Lunar Orbiter missions 30, 31

M

McCandless, Bruce 40
McDivitt, James A. 28
Marden, Luis 27
Mercury missions 12, 20, 26–27

Meyer lenses 22
mission control centres 40, 41
mission timeline 12–15
Moon, images of 90
Copernicus crater 30, 31
Daedalus craters 63
farside 33
Mare Smythii 64
Sea of Tranquillity 43
stereoscopic print 18
Morse, Ralph 27
Mydans, Carl 27

N

NASA, photography and 8, 27, 28,
31, 34, 38, 44
Nasmyth, James 19
Nixon, Richard M. 51

R

Ranger probes 31
Réseau plates 38
Royal Swedish Air Force 22

S

Sason, Sixten 24
satellites 20
Saturn V launch vehicle 6, 42
Schirra, Wally 8, 26, 27, 32

Schmitt, Jack 34
Schneider lenses 22
Scott, David 32
Shepard, Alan 20
space race 20
Sputniks 20
Surveyor probes 31

T

Tereshkova, Valentina 20
Titov, Gherman 20

Verne, Jules 19
Vostok-1 20

W

wet collodion process 19
Whipple, John Adams 18
White, Edward 28, 32
Williams, Roland 27

X

Xenotar lenses 14

Z

Zeiss, Carl 38
Zeiss lenses 12, 13, 14, 15, 22,
26, 28, 34, 38

ACKNOWLEDGMENTS

I would like to thank the staff of the Hasselblad Foundation who assisted with this project, particularly Dragana Vujanovic Östlind, Chief Curator, Jenny Blixt, Public Relations Officer and Elsa Modin, Librarian, who supplied the two 500 EL images and the portrait of Victor Hasselblad. Thanks go to Harald Benker of Auction Team Breker for his help in supplying the photograph of the Hasselblad HK7. For their kind assistance, Keith Haviland, CEO/Producer Haviland Digital and Bobby Livingstone, Executive Vice President of RR Auctions.

Special thanks go to Dr Michael Pritchard FRPS for his support and writing the foreword, and to Richard Ireland for his help and encouragement.

This book would not have been possible without the generosity of NASA. In making available its archives for research, study and education it has provided one of the most dynamic reference sources for science and the history of space exploration in the world. Not only does it provide the opportunity for in-depth study for the science of space, it acknowledges the role played by all astronauts from around the globe.